Port Hope Ontario Book 2 in Colour Photos, Saving Our History One Photo at a Time

Photography
by Barbara Raué
©2019

Series Name: Cruising Ontario

Book 231: Port Hope Book 2

Cover photo: 175 Dorset Street West, Page 67

©All the photos in this book have been taken with my cameras. I own the rights to them.

Series Name: Cruising Ontario
Saving Our History One Photo at a Time
in colour photos

Books Available in Alphabetical Order:
Aberfoyle, Acton, Ajax, Alton, Amherstburg, Ancaster, Arthur, Auburn, Aylmer, Ayr, Beaver Valley, Belgrave, Belleville, Bloomingdale, Blyth, Brantford, Brockville, Burford, Burlington, Caledon, Caledonia, Cambridge, Carlow, Chatsworth, Clifford, Collingwood, Conestogo, Delhi, Dorchester to Aylmer, Drayton, Drumbo, Dundas, Dunlop, Eden Mills, Elmira, Elora, Erin, Essex, Fergus, Goderich, Grimsby, Guelph, Hagersville, Hamilton, Hanover, Harriston, Hespeler, Jarvis, Kingston, Kingsville, Kitchener, Lake Superior, Lincoln, Linwood, Listowel, London, Lucknow, Merrickville, Mono, Mount Forest, Mount Pleasant, Neustadt, New Hamburg, Newboro, Newport, Niagara-on-the-Lake, Niagara Falls, North Bay, Oakville, Onondaga, Orangeville, Orillia, Oshawa, Owen Sound, Palmerston, Paris, Pelham, Perth, Peterborough, Petrolia, Pickering, Port Colborne, Port Elgin, Portland, Preston, Rockwood, Sarnia, Sault Ste. Marie, Seaforth, Sheffield, Shelburne, Simcoe, Smiths Falls, Smithville, Southampton, St. Catharines, St. George, St. Jacobs, St. Marys, St. Thomas, Stoney Creek, Stratford, Thamesford, Thunder Bay, Tillsonburg, Toronto, Waterdown, Waterford, Waterloo, Welland, Wellesley, West Flamborough, Westport, Whitby, Windsor, Wingham, Woodstock

Book 216: Sudbury
Book 217: Parry Sound
Book 218-219: Uxbridge
Book 220: Port Perry
Book 221-222: Stouffville
Book 223: Colborne

Book 224: Bolton/Grafton
Book 225-229: Cobourg
Book 230-232: Port Hope

Table of Contents

John Street	Page 5
South Street	Page 17
Mill Street South	Page 19
Mill Street North	Page 23
Ganaraska River	Page 30
Cavan Street	Page 34
Augusta Street	Page 42
Dorset Street West	Page 52
Dorset Street East	Page 68

Port Hope is a heritage community situated on the north shore of Lake Ontario in Northumberland County and offers both an urban and rural paradise with the perfect combination of heritage charm, modern vibrancy and cultural allure. The Ganaraska River runs through the heart of town past historic buildings.

The Township was opened in 1792 and named in honor of Colonel Henry Hope, a member of the Legislative Council of Canada.

Before Canada became a nation in 1867, Port Hope was already a boomtown. Its main streets were thronged with horse-drawn carriages and farmers' wagons, its plank sidewalks crowded with shoppers and merchandise. Wood-burning locomotives pulled heavily loaded trains through town on their way to a harbor filled with schooners and steamships. Solid brick commercial blocks and houses lined the streets.

The town grew rapidly from four families of English descent who arrived by boat in 1793 and settled at the river mouth. Until then the area had been home to aboriginal groups — Huron, then Iroquois, and finally Mississauga — attracted by the salmon and sturgeon that swarmed in its river.

The first European settlers came from the new United States. They had chosen to follow the British crown after the American Revolution. More families arrived including blacksmiths, carpenters, bricklayers, and merchants. The mills drew farmers from fifty and sixty kilometers away. Grain that could not be milled was bought by distilleries — there were eventually five along the river — that produced a famous Port Hope whisky. In 1856 the Grand Trunk Railway connected Port Hope to Toronto and the Atlantic seaboard. Its viaduct over the Ganaraska River was the second greatest engineering challenge on the route, exceeded only by bridging the St. Lawrence River at Montreal.

Another railway heading north from Port Hope opened up the vast timberlands and new farms of central Ontario and stretched to Peterborough and Lindsay. Eventually it reached Georgian Bay, at Midland. Down this line came great loads of timber and grain. Some went east to England, but most was exported to the USA through Rochester across the lake.

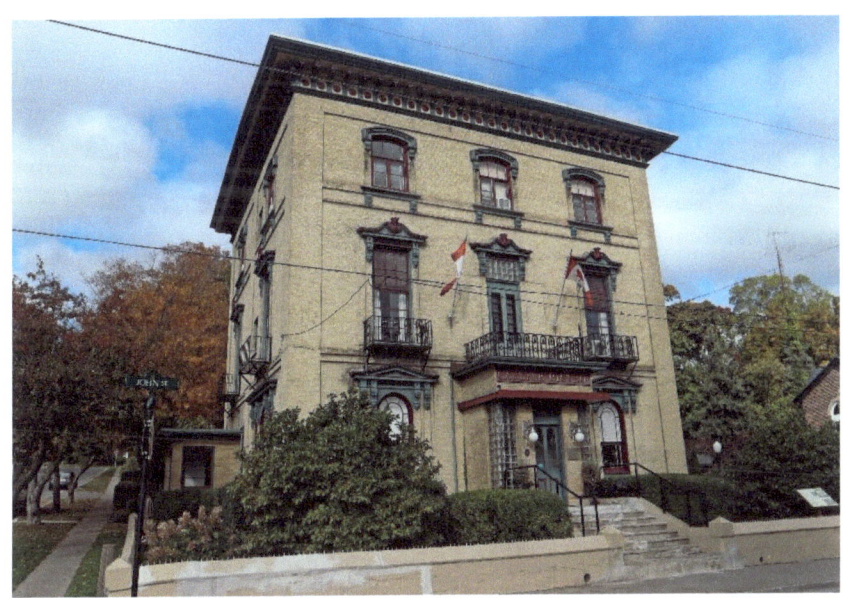

86 John Street - The Bank of Upper Canada – c. 1857 - The three-storey brick structure is almost square and is a good example of Italianate architecture with a flat roof, protruding eaves supported by ornamental molded brackets, tall and round-headed windows and decorative window trim. The exterior walls have recessed panels in the brickwork and the white brick was manufactured in Toronto. A stone band course separates the coursed rubble foundation from the brick structure. On the main façade, there are nine openings, two windows and one entranceway on the first storey, and three windows on each of the second and third floors. The first storey windows are round-headed and six over three double hung with a round-headed centre pane and five surrounding panes over three vertical panes. These windows are surmounted by moulded wooden "pedimental" surrounds. Double pilasters on each side are formed out of the brick.

The second storey windows are flat six over nine double hung sash, surmounted by molded "entablature" surrounds with a central flourish, and bordered by single brick pilasters. The center window has been replaced by French doors, and opens out to the cast iron railed balcony on top of the front porch. The original cast iron balconies of the other second storey windows have been replaced by plain modern iron rails. Three projecting rows of brick form the sills on the second storey fenestration. The third storey windows have segmental molded wood heads, and have brick pilasters at the sides, and wooden lugsills with supporting brackets.

The Bank of Upper Canada was established in York (Toronto) in 1822. Until its demise in 1866, the bank was one of British North America's leading banks. It played a significant role in the financial development of Upper Canada.

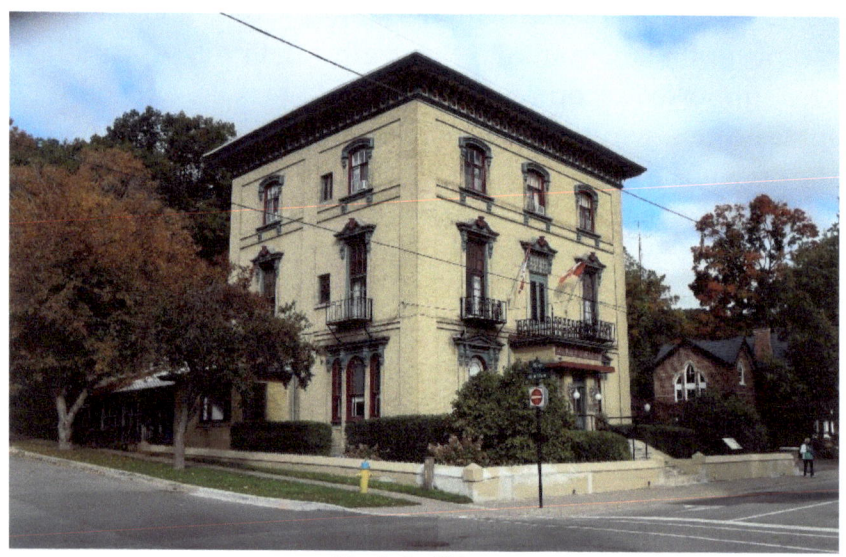

Carlyle Bistro

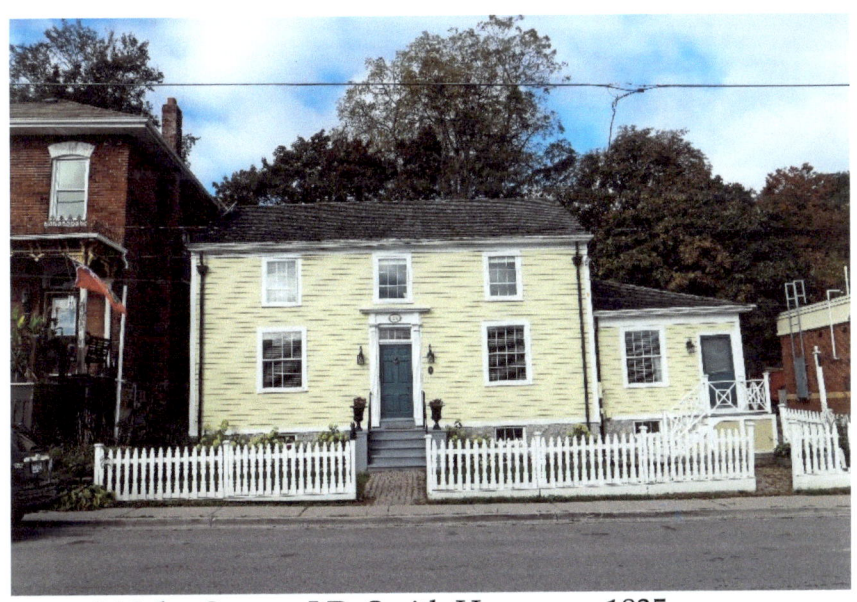

94 John Street - J.D. Smith House – c. 1835 - symmetrical arrangement of windows around the central front door with pilastered doorcase and transom, two-storey gable roof with brick end chimneys, timber frame construction sheathed in clapboard. A one storey hipped roof addition is at the side, and if not original is fairly early; it provided a separate entrance to the taproom.

The house had its historic beginnings as a local tavern.

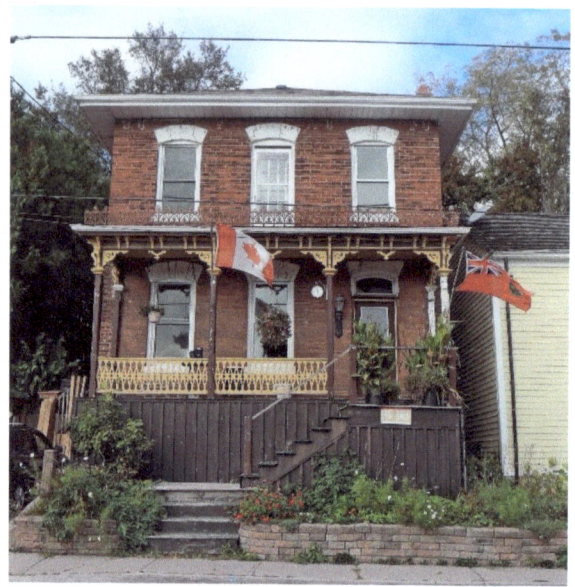

96 John Street

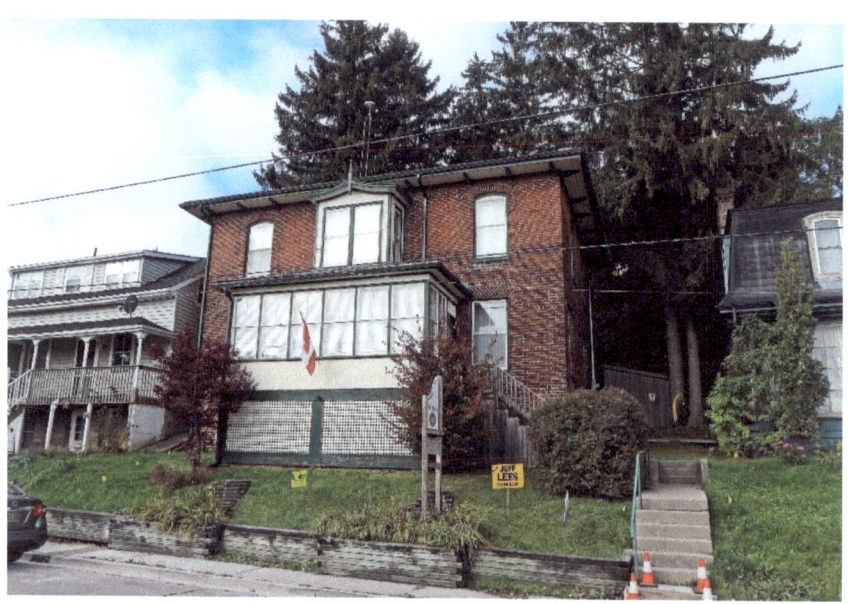

100 John Street

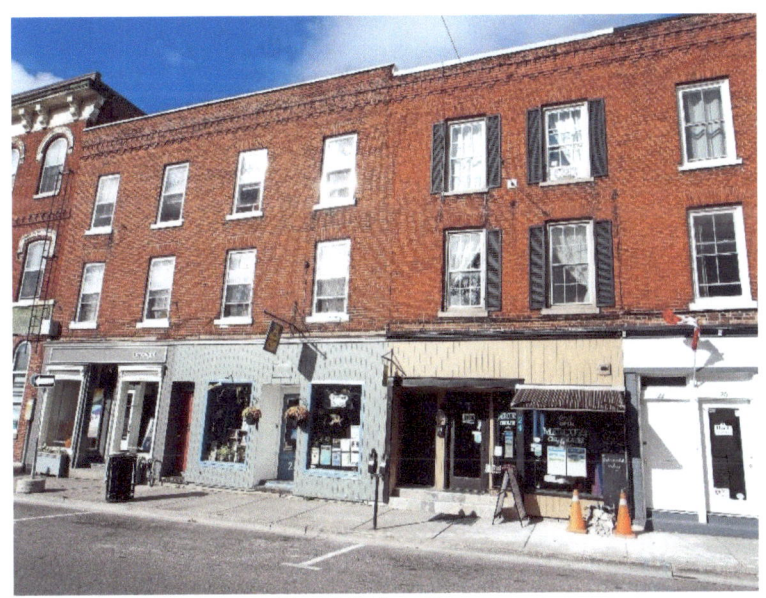

20-28 John Street

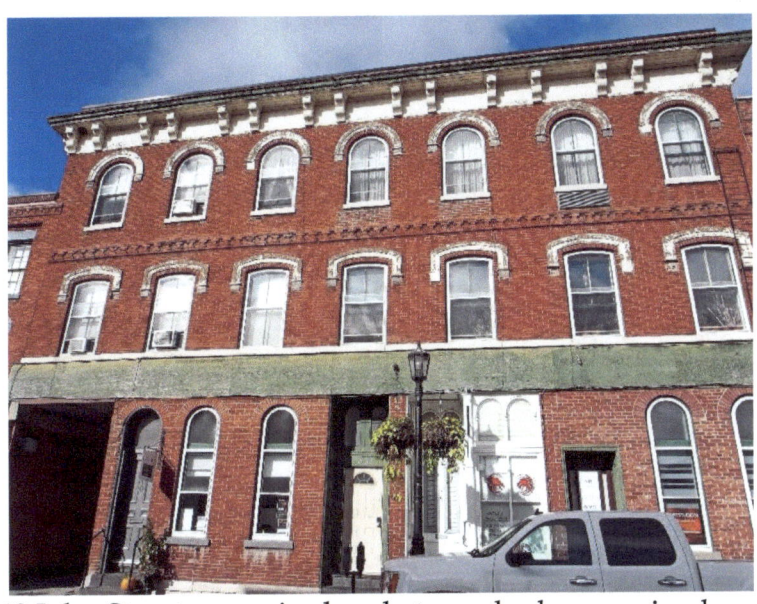

34-40 John Street – cornice brackets, arched voussoirs, beveled dentil molding

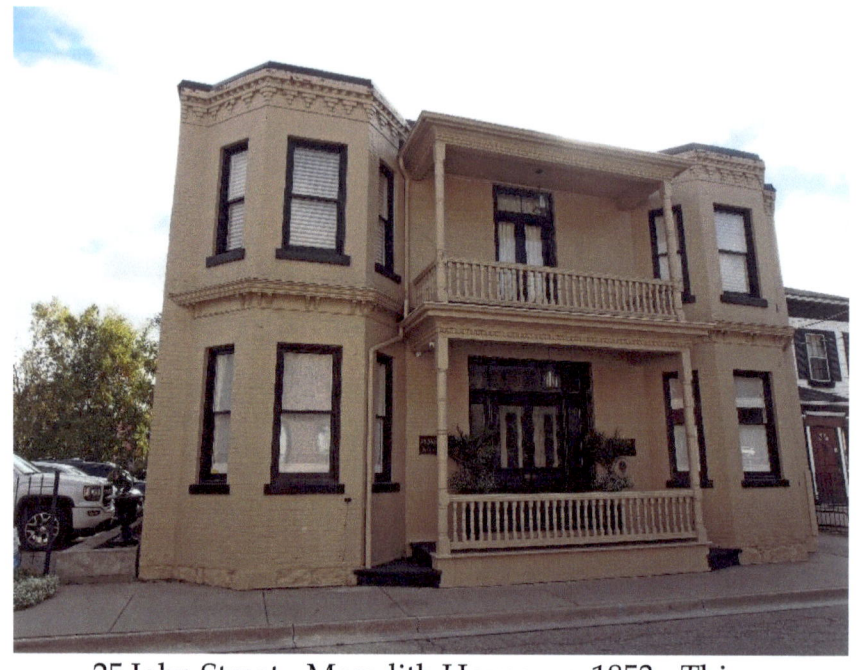

25 John Street - Meredith House – c. 1853 - This symmetrical design with two-storey bay windows flanking the wide double entrance is a good example of late Victorian brick building. Decorative trim appears on the front facade. A flat roof, simple chimney, and two-storey verandah are additional features.

27 John Street - The Cochrane House – c. 1848 - This two and a half storey frame dwelling is an early example of the Greek Revival. It is a square house with a side-hall plan and gable roof. The main facade has three bays and the main entrance to the house is located on the north side of the facade. The entrance is simple, yet gracefully done. The wide, closed transom, with its plain entablature, helps to frame the entrance. On either side of the door are plain, wooden pilasters. The entrance is reached by a wide flight of stairs. All of the windows have the original sashes of six panes over six panes. They all have moulded wooden surrounds and flush wooden sills.

The Cochrane House is named for James Cochrane, the original owner and proprietor of the Queen's Hotel (81 Walton Street). James Cochrane (1815-1900) was born in County Down, Ireland in 1815. He came to Canada in 1841, and settled in Port Hope. In 1871, he built the Queen's Hotel.

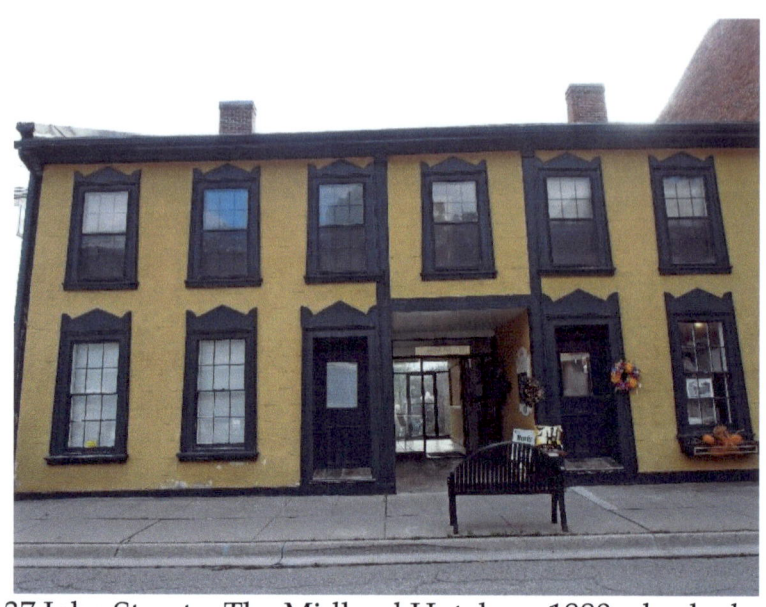

33-37 John Street – The Midland Hotel – c. 1880 – backed onto the railway tracks and station

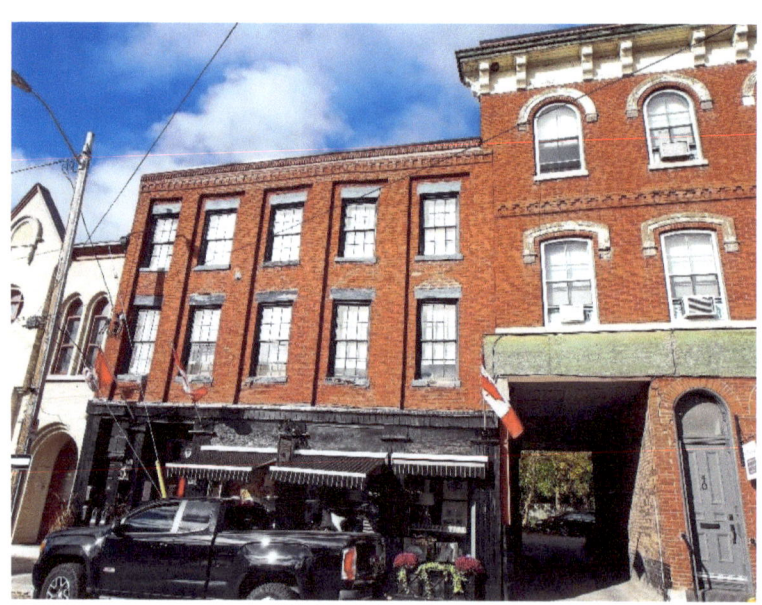

40-48 John Street

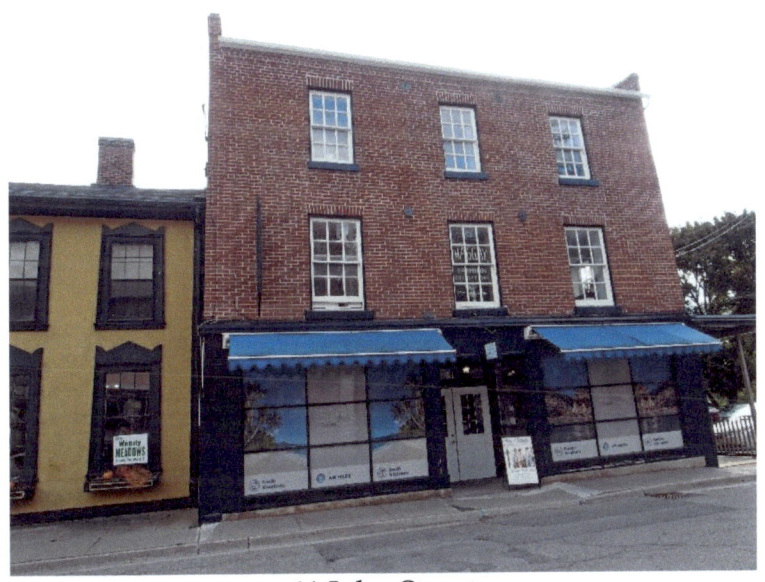

41 John Street

49 John Street

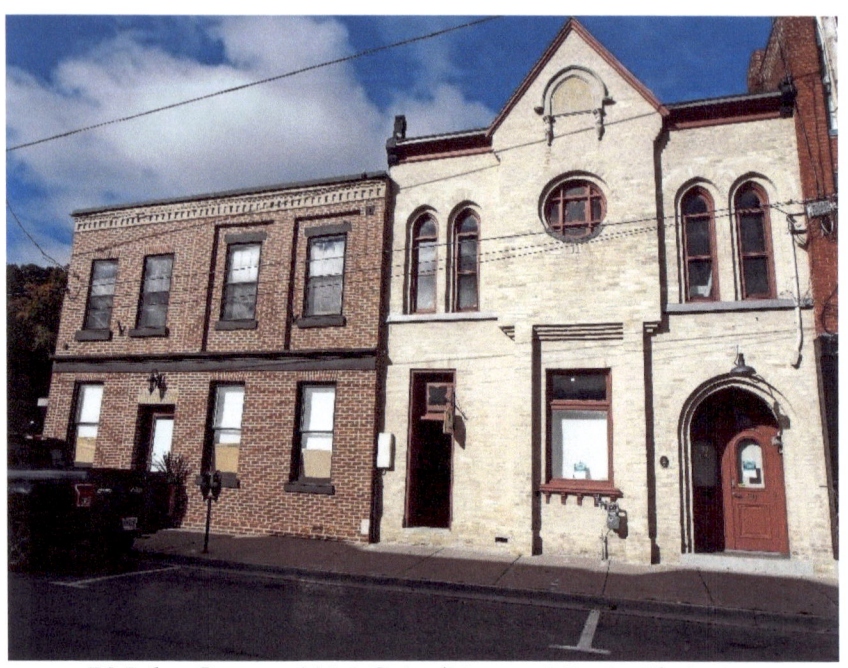

50 John Street - Y.M.C.A. (Young Men's Christians Association) – c. 1874 - The main floor of the two-storey front contains round arched main entrance (asymmetrically placed) and secondary flat-arched entrance at left. Between are brick pilasters enclosing a plain window and transom. The second storey has a central projecting panel into which a circular window with quatrefoil glazing is placed. Twinned narrow windows, symmetrically placed, complete the composition. Separating the two storeys is a band course. The cornice is molded and at centre is an unusual peak with applied ornament. The roof is of the shed type.

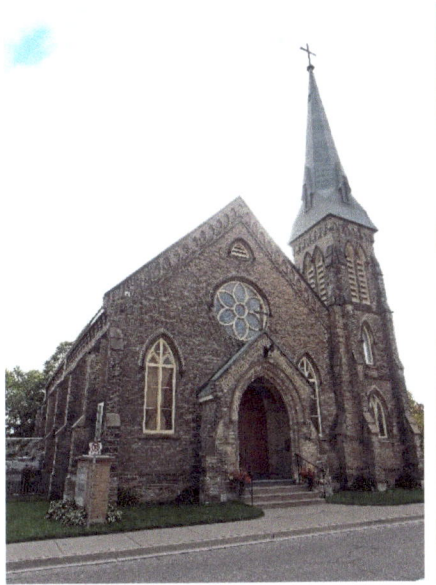 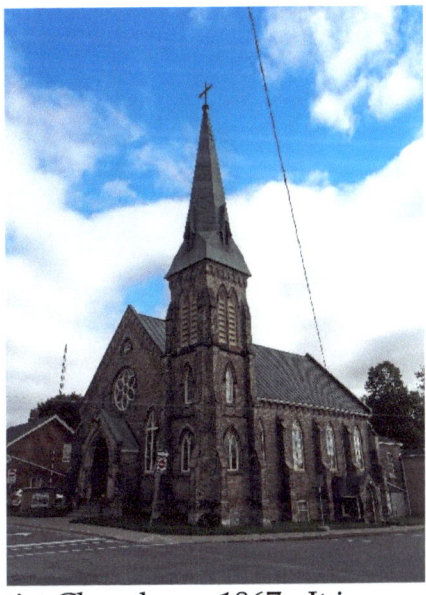

57 John Street – First Baptist Church – c. 1867 - It is a buff-brick structure, gable-roofed, on a stone foundation. The spire roof is copper, last replaced in 1964. The facade faces John Street with the tower and spire placed strategically toward the corner of Augusta. The facade is symmetrically arranged around a front entrance bay. The open, roofed vestibule, with Gothic arch, is elaborated with corbelled brick, buttresses and decorative scrollwork announcing "Baptist Church 1867". Windows on the facade are twinned Gothic lights under a wider Gothic arch. The arch is decorated with stone and brick masonry. A rose window with a vent above completes the facade. Ornamental brick cornice accents the front gable and continues around the side elevations. The side elevations are buttressed with tall Gothic windows placed between. The tower and spire are placed to the side with buttresses on the tower and Gothic openings. The ornamented cornice continues on the tower. The polygonal spire reaches skyward, topped with a cross.

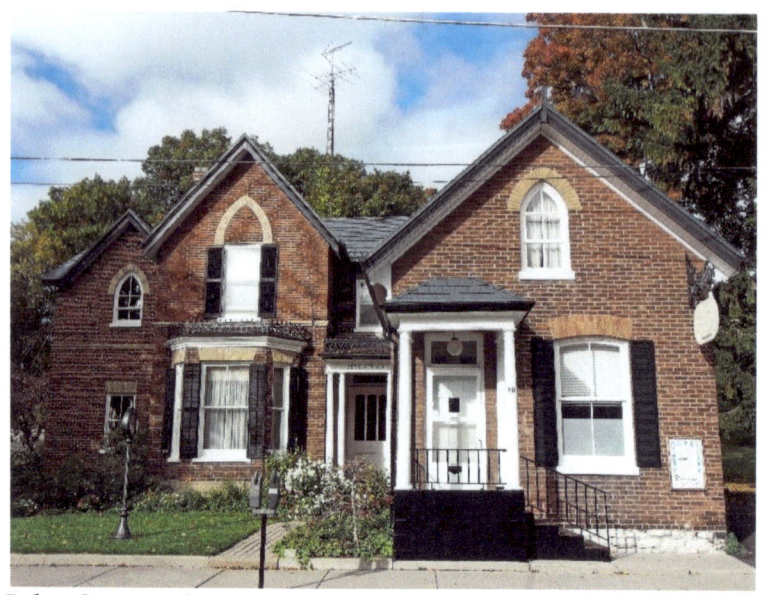

76 John Street – bay window, iron cresting, Gothic windows, Doric pillars

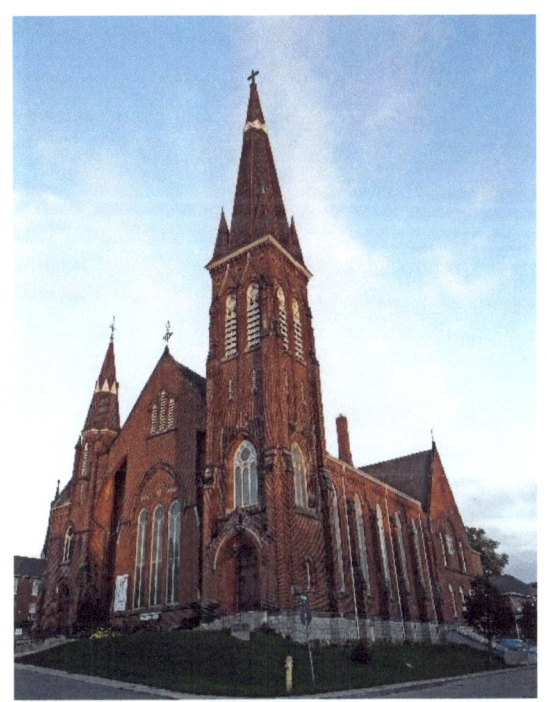

34 South Street – Port Hope United Church

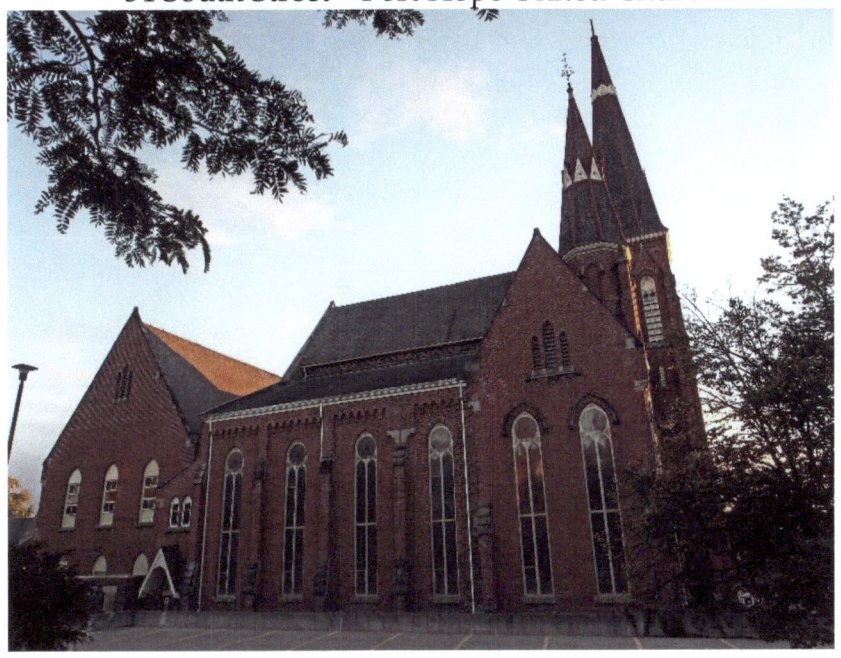

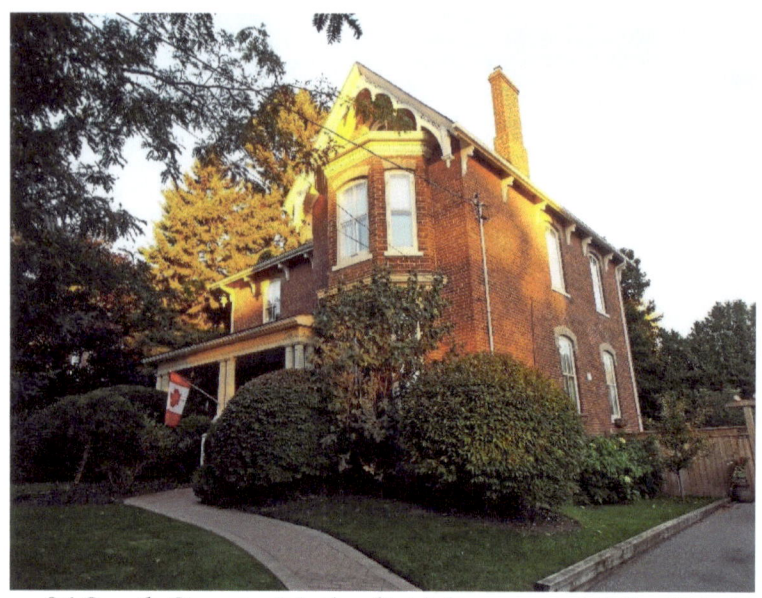

36 South Street - Methodist Manse – c. 1875 - This late Victorian red brick house has an asymmetrical plan with its protruding bay and wide columned porch. It has a steeply pitched roof supported with wood brackets and decorated with a delicate and elegant bargeboard trim.

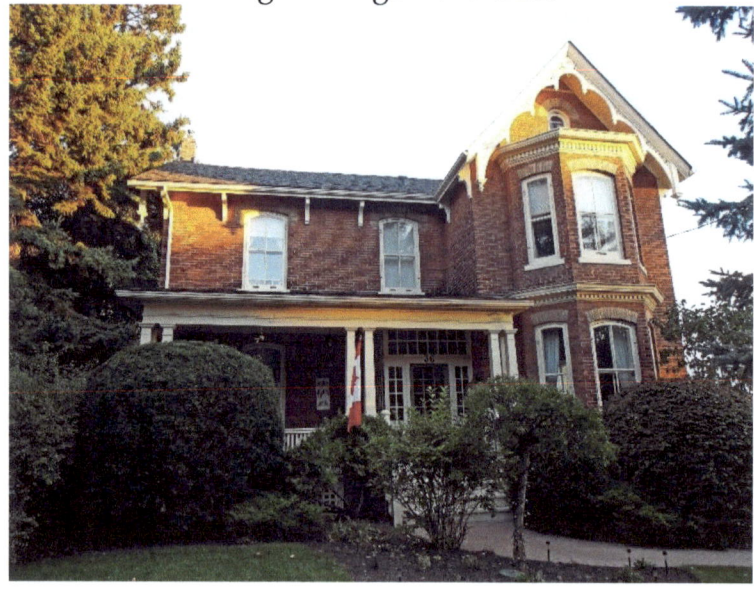

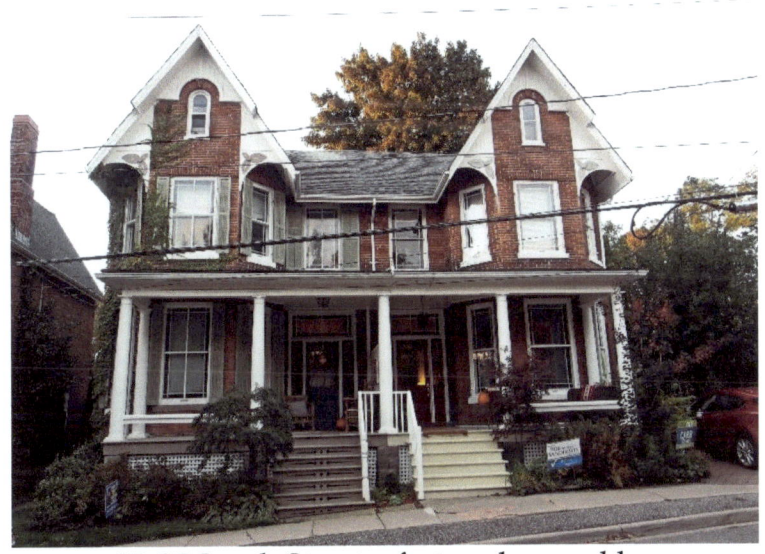

35-37 South Street – fretwork on gables

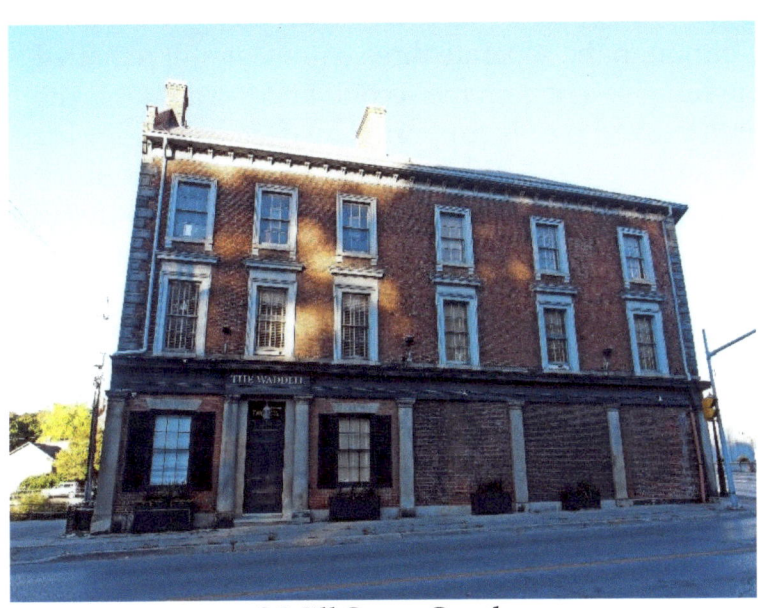

2 Mill Street South

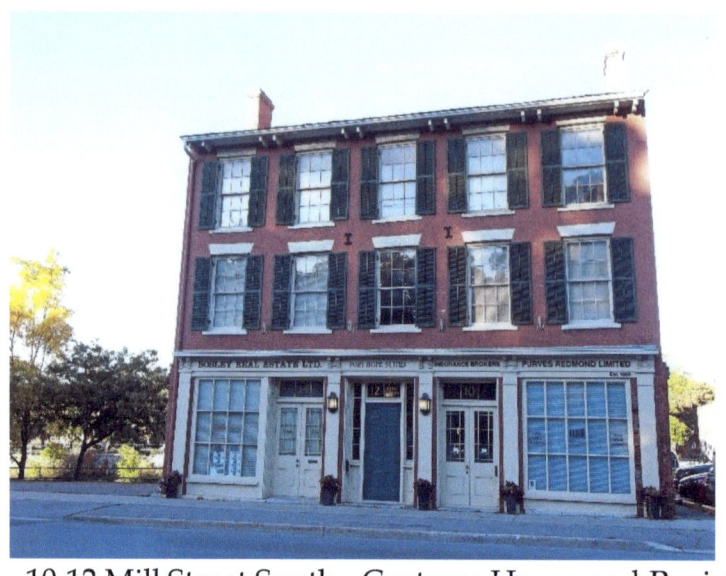

10-12 Mill Street South - Customs House and Registry Office – c. 1845 - This three-storey parapet gabled brick commercial building retains its original features on the upper storeys but has been considerably altered on the ground floor level, although the separate three entrances still remain. Five double-hung sash are on the second and third floors. The medium peaked roof is supported by decorative eave brackets on the front façade. A wooden shop front cornice runs along the front façade. T. Ward was the Registrar during that period and by 1853 this building was being used as the Customs House and Registry Office. Port Hope was constituted as a port of entry in 1819, however, it was not until 1829, that a harbour was established. A wharf was constructed on the east side of the river and a pier was established on the west side. By the late 1840s, Port Hope was a bustling port and busy commercial area; modifications and expansions were made to the harbour in the ensuing decades. As a port of entry, a Customs House was required. Additionally, the building served as the Registry Office, a repository of legal land transactions until 1871, when a separate Registry Office was built on the north side of Mill Street (17 Mill Street North).

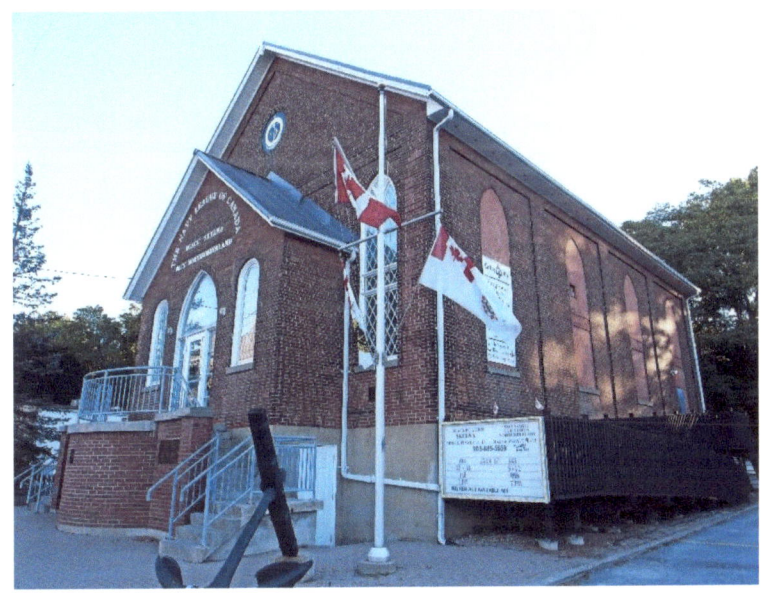

17 Mill Street South – The Navy League of Canada Northumberland Branch

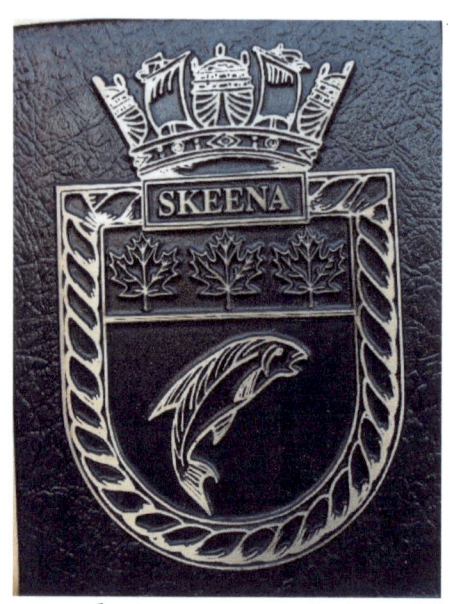

HMCS Skeena was a destroyer commissioned into the Royal Canadian Navy on June 10, 1931. It fought in the Battle of the Atlantic from 1939; she defended the Allied landings in France from U-boats and hunted them until she was wrecked on Videy Island, Iceland with the loss of fifteen men on October 25, 1944.

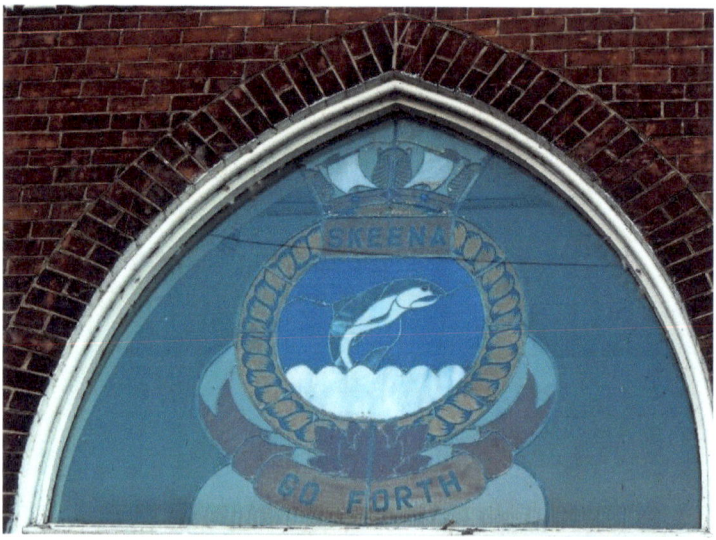

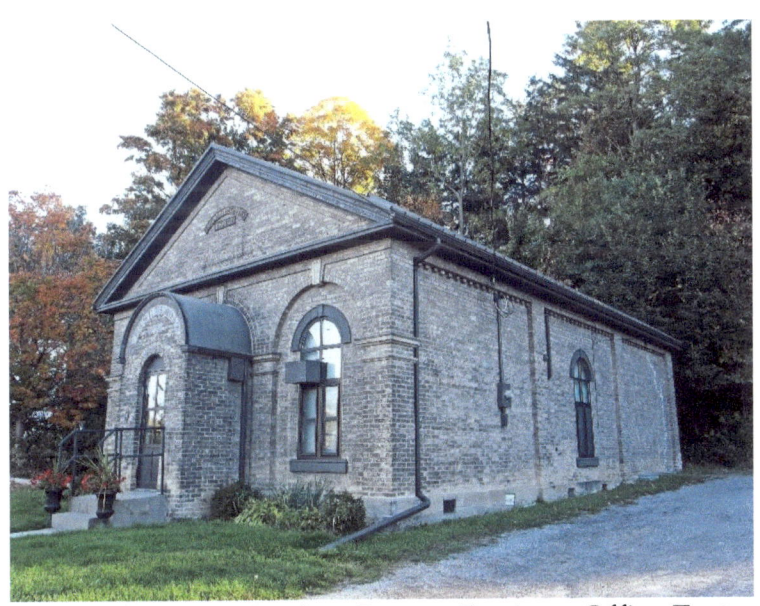

17 Mill Street North – County Registry Office East Durham – c. 1871 - The Land Registry Office is an attractive Neo-Classical brick building, simple in its single storey silhouette and gable roof of medium pitch. The gable end, which forms a triangular pediment, faces the street and presents a three-bay facade with projecting vestibule. All the door and window openings are crowned with true semi-circular arches. On the facade these are recessed into arched brick panels and topped with keystones. Band courses in brick and a plinth add decorative emphasis to the masonry. Still visible and of significance is the painted sign over the front door that reads "East Durham 1871.

The structure is unique, composed of three brick vaults that run across the width of the building. The building's prime objective, fireproofing, was essential to its role as a safe depository for all legal documents affecting land ownership. It follows a plan established by the provincial government in the 1870s.

31 Mill Street North

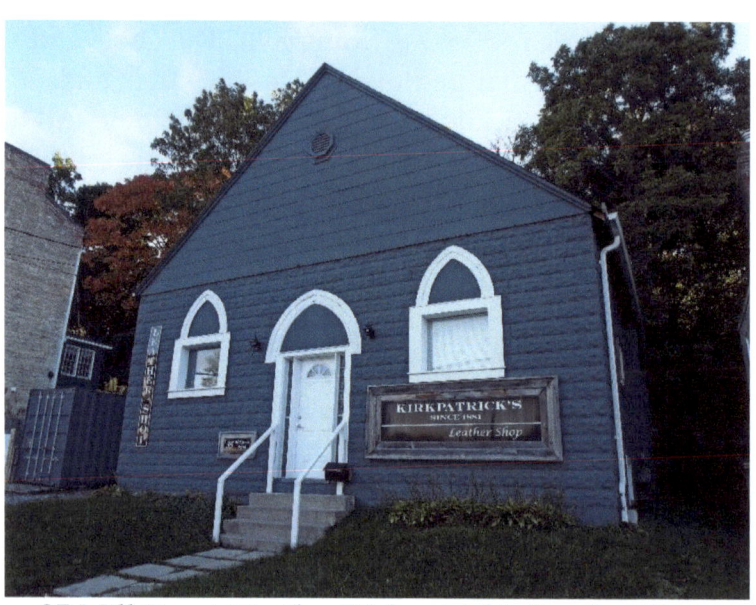

35 Mill Street North – Kirkpatrick's Leather Shop

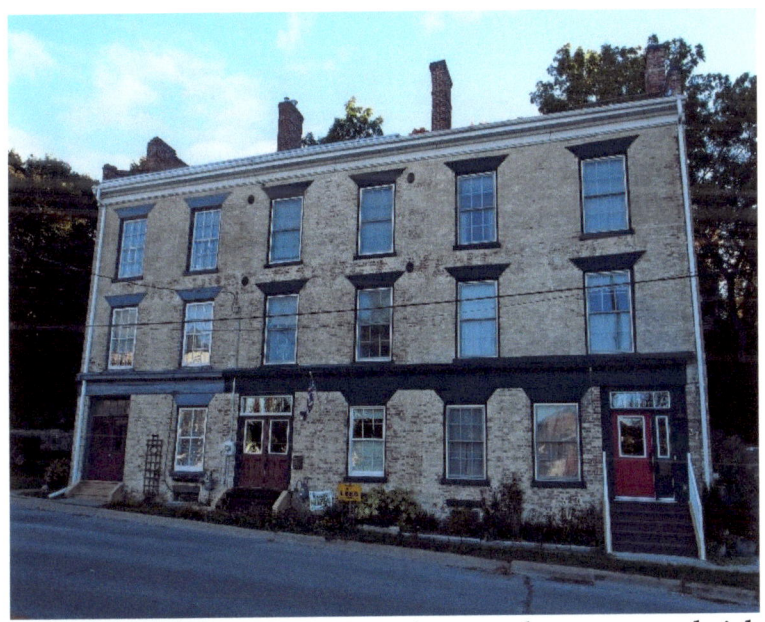

37-41 Mill Street North – This is a three storey, brick building with gable roof with parapet walls and end chimneys. The windows at street level are conventional sash. At second and third storeys, the windows are glazed in original six over six sash. The brick arches are remarkable for the angle of their splay, which creates a decorative pattern unusual in Port Hope. The upper cornice is distinguished by a decorative bracket and moulded boards.

41 Mill Street – Crawford Block – c. 1848 - is the north third (left of picture) of a very important terrace. Henry Howard Meredith purchased the Crawford Block in July 1853. Robert Crawford, a saddler and tanner located on Ward Street, had built the block.

In 1853, Henry Howard Meredith acquired this block of townhouses. In a rental advertisement of 1860, he described the townhouses as "three comfortable three storey Brick Dwelling houses on Mill Street North of the Post Office. These houses are particularly well adapted for persons requiring residences in the business part of Town, or for persons wanting a dwelling house with offices adjoining".

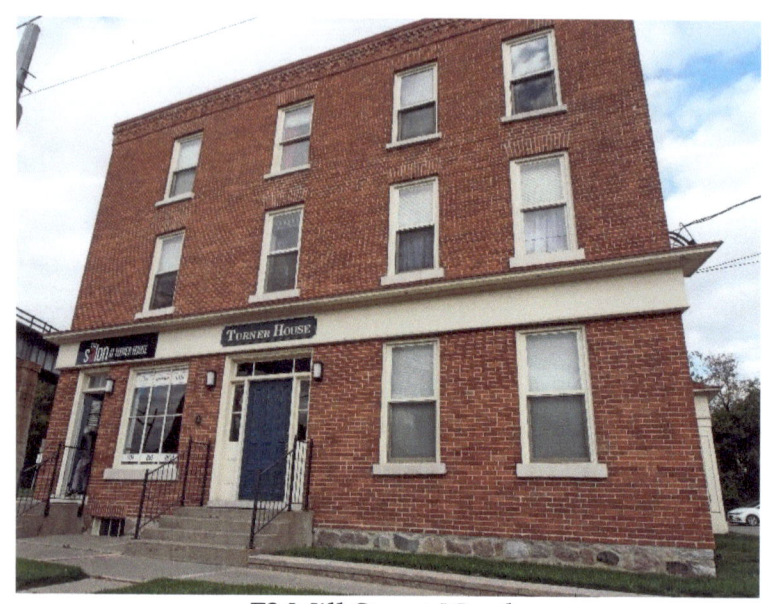
73 Mill Street North

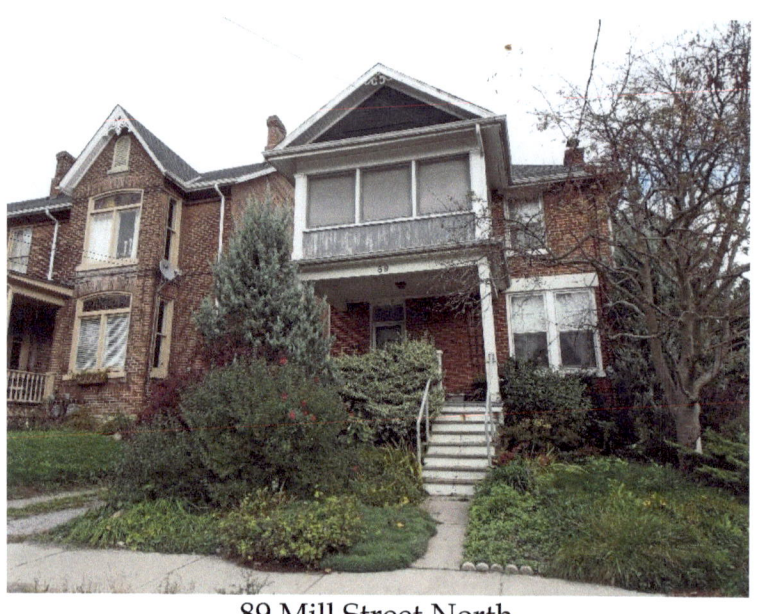
89 Mill Street North

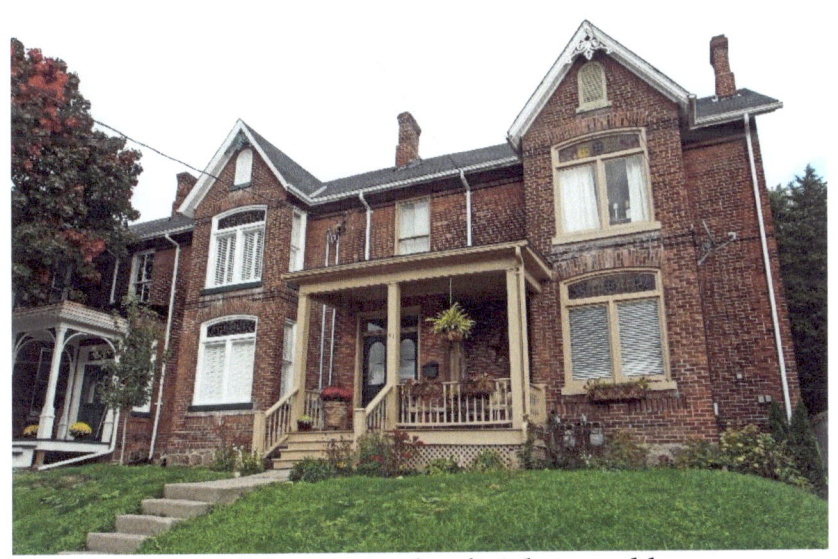

91 Mill Street North – finials on gables

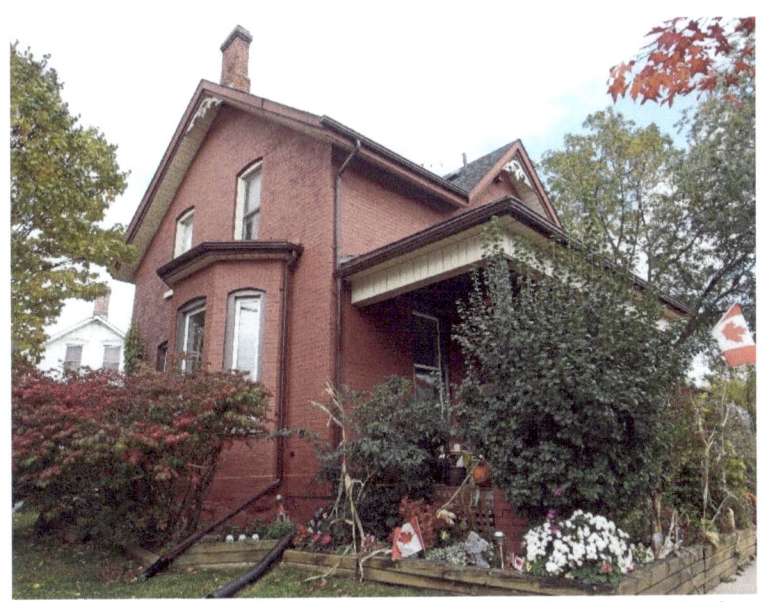

93 Mill Street North – trim at top of gables, bay window

91-93 Mill Street North - Deyell Terrace – c. 1890 - 91 and 93 Mill Street are, respectively, the south and middle sections of a row of three attached related buildings. The two-bay, two storey houses are constructed of brick laid in garden wall bond. The roof is of medium pitch with a front gable containing a decorative finial.

The doorways are in a projecting frontispiece and are composed of paired doors containing long round-headed windows with square panels below. A transom with one dividing muntin is contained above. The windows in the projecting frontispiece below the gable are Edwardian in style with segmental stained-glass transoms above two vertically divided panes. A small mainly decorative round-headed louvred window is placed below the gable.

A decorative string course of dark brick runs below the eaves line. A section of corbelled brick is situated below the large ground floor windows. The foundation is of coarse rubble. There are four chimneys on the front and four on the rear of the roof. The wooden porches with three supports each may be later additions.

Robert Deyell (1850-1838) was born in Ontario. Deyell's father, James, established the first gristmill at Millbrook in the 1840s. Robert was a druggist who established his business in 1870 in partnership initially with John B. Woolhouse (who had established a drugstore in 1860), then later on his own. His drug store was located on the corner of Ontario and Walton Street in the Wilson's Block (70-76 Walton Street). He resided on Brown Street (90 Brown Street).

Mill Street North – bay window

103 Mill Street North – D. E. Allison Funeral Home

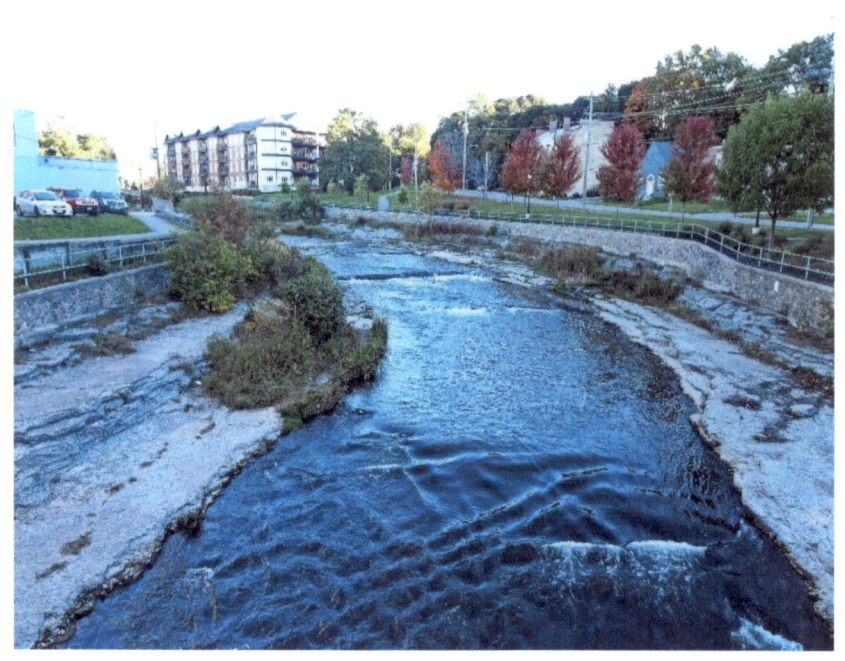

Ganaraska River

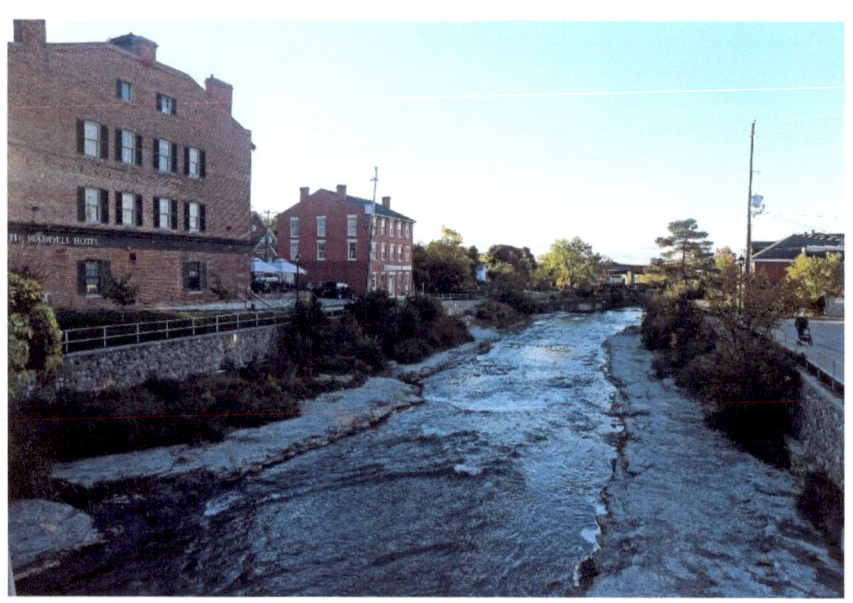

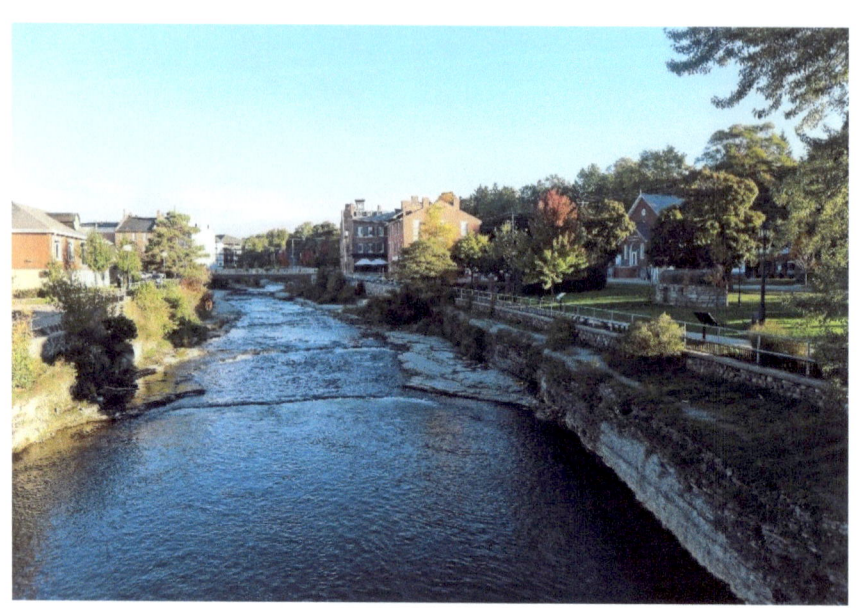

Ganaraska River

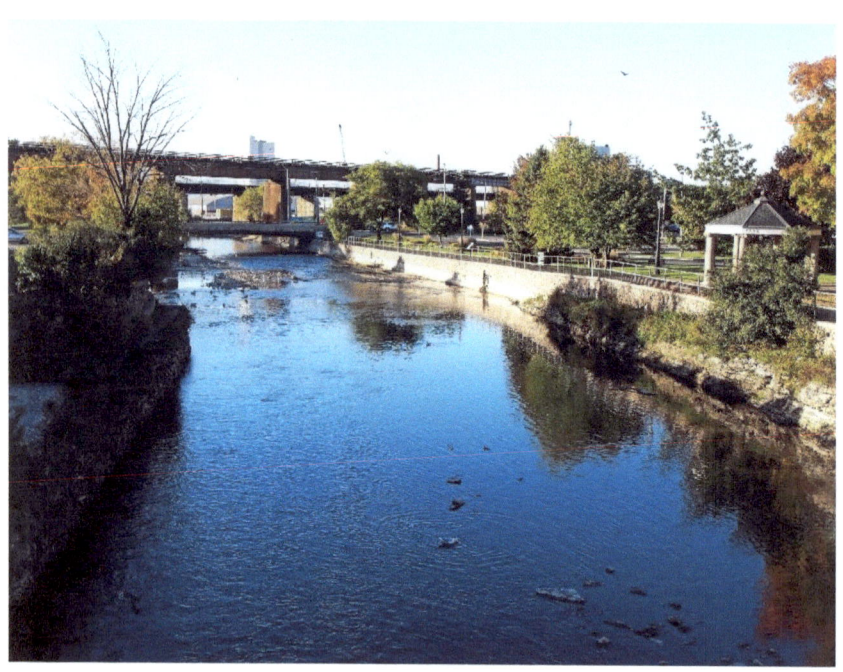

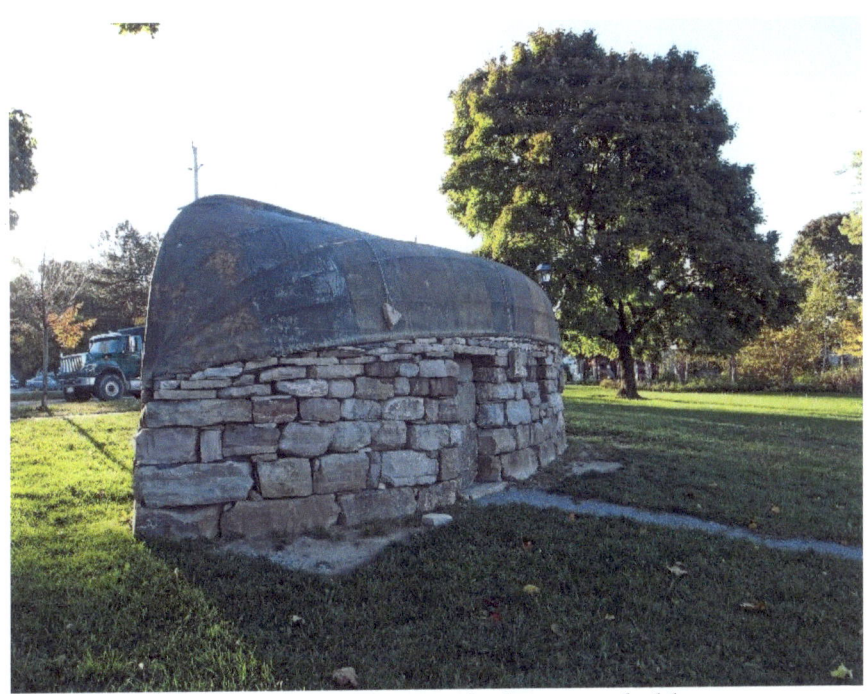

The monument is a scale model of a boat-roofed house constructed with stone and topped with an overturned walrus skinned sailboat. The monument is a tribute to Farley McGill Mowat, a fervent environmentalist and one of Port Hope's most distinguished and celebrated residents.

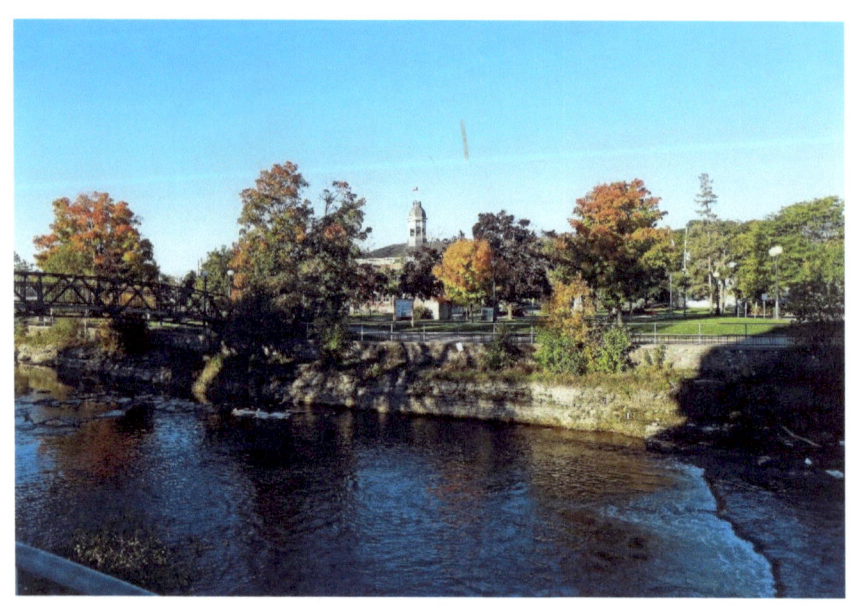

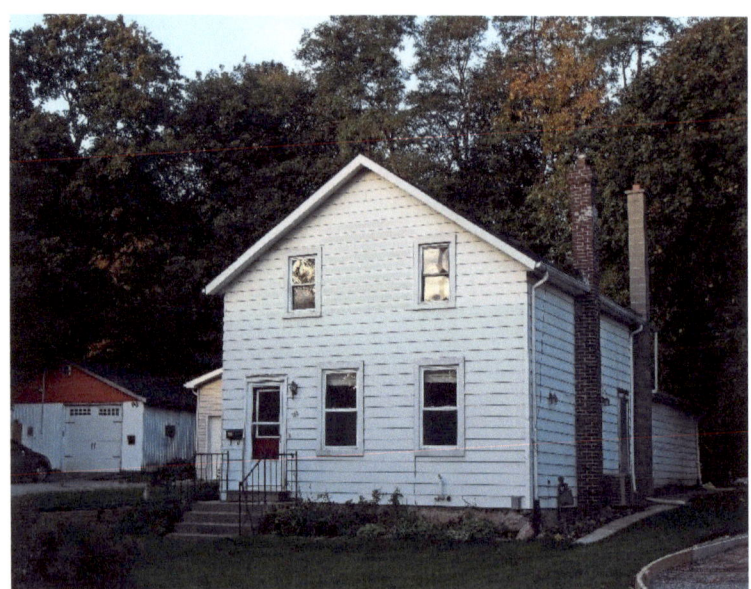

102 Cavan Street

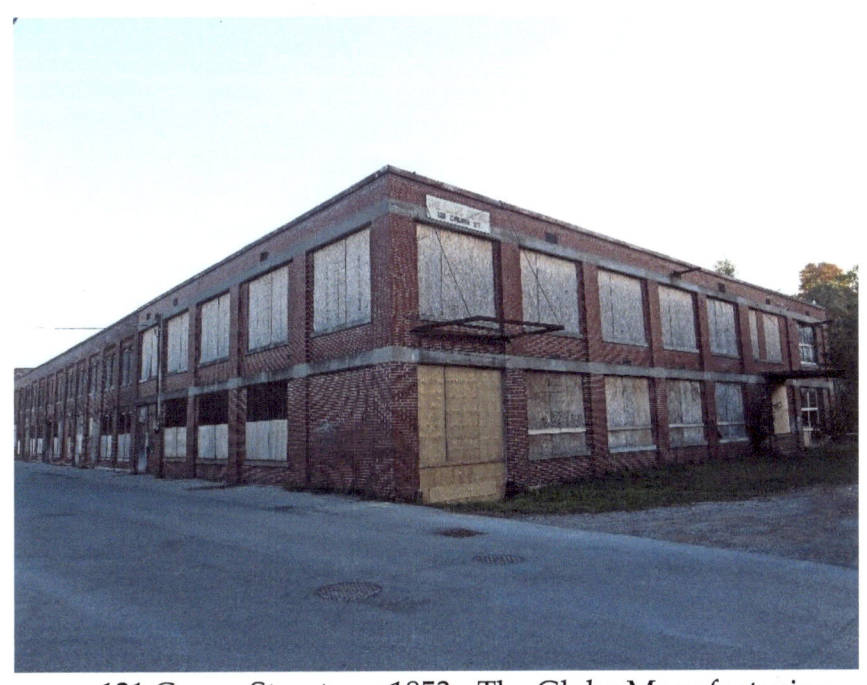

121 Cavan Street – c. 1853 - The Globe Manufacturing Company was established in Port Hope in the early 1830s. In 1853, the first phase of the factory was built. It was later known as the Black Diamond and Nicholson File Factory. Over the years of its operation from 1853 to 1976, new buildings were added to the original structure as the business expanded. The original Globe Manufacturing building included a mill powered by the Ganaraska River.

For many years the factory produced tools, primarily files and related tools.

96 Cavan Street

78 Cavan Street

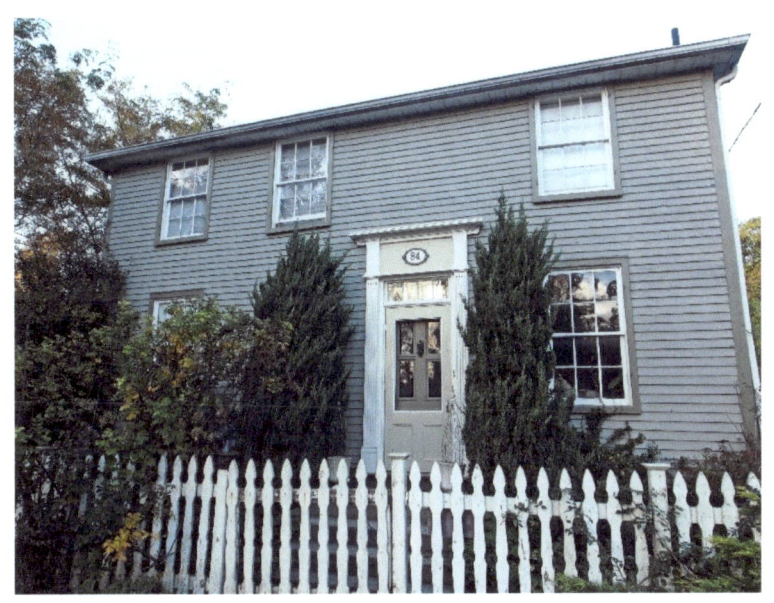

84 Cavan Street

76 Cavan Street

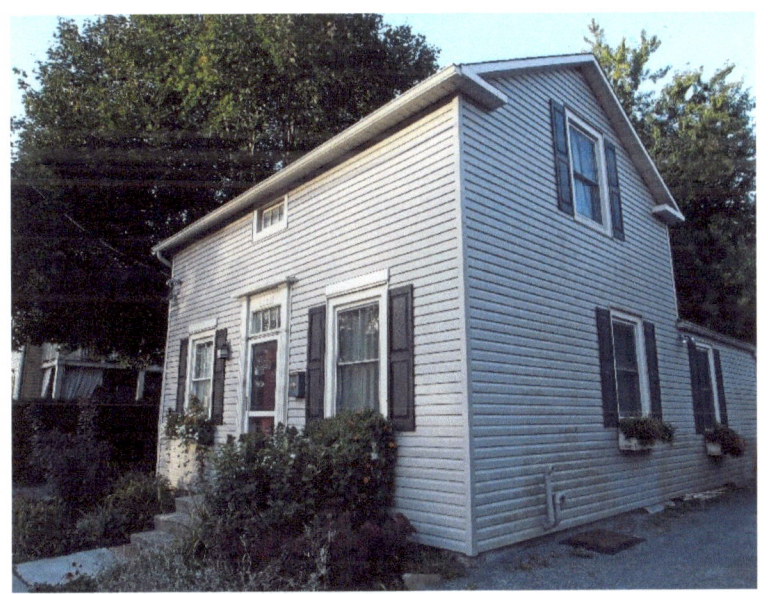

74 Cavan Street

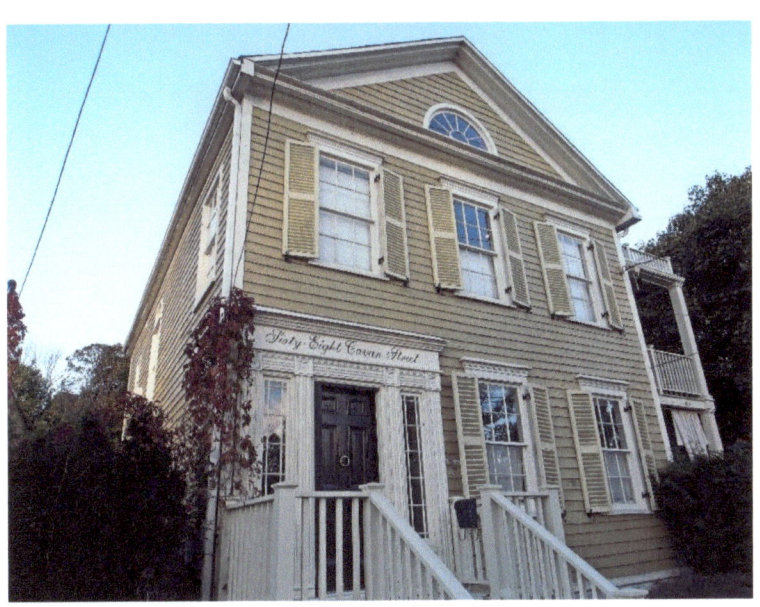

68 Cavan Street

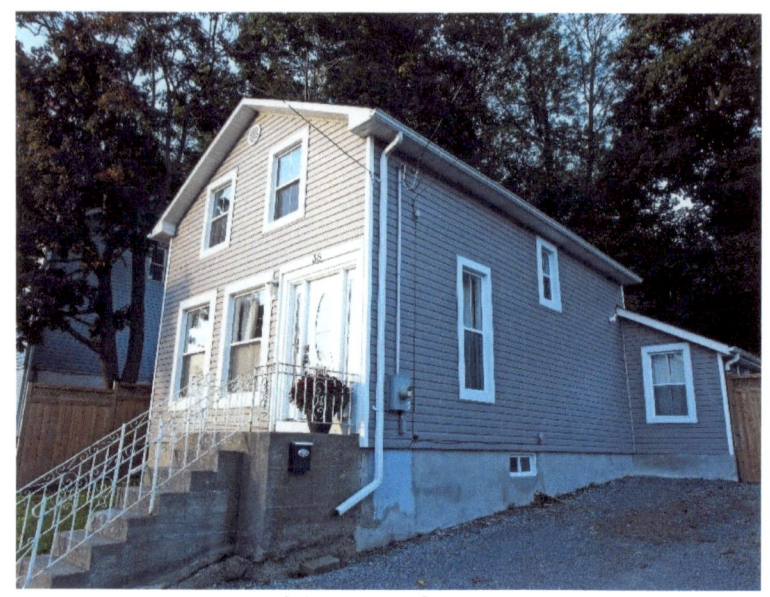

36 Cavan Street

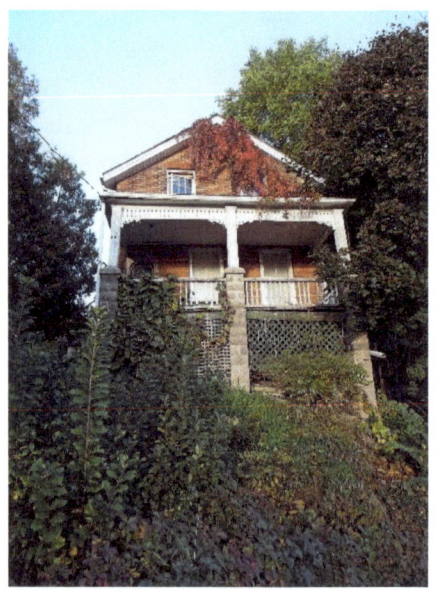

26 Cavan Street

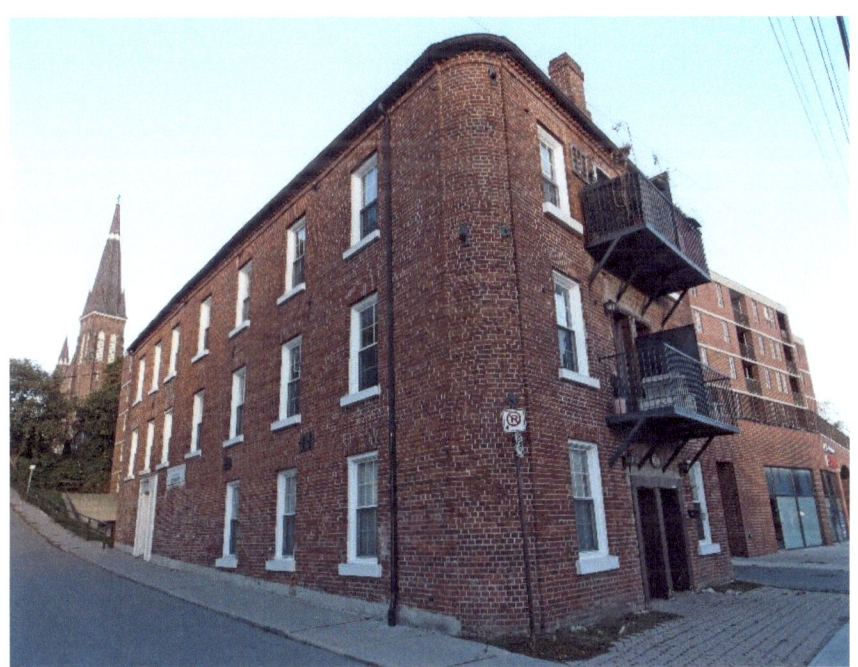

46 Cavan Street – c. 1842 - The Chalk Works is one of the few buildings that remain from Port Hope's industrial heyday. The brick structure stands three storeys high with a gable roof, rounded corner in header bond.

Robert Chalk (1820-1890), an English immigrant born in Biddeford, Devonshire, England, settled in Port Hope in 1842 at the age of 22, and established a wagon and carriage-making business. Chalk Carriage Works was located on Cavan Street on the steep hill where South and Cavan Street meet, a hill that was sometimes referred to as Chalk's Hill. Many of Port Hope's early industries were located on Cavan Street on the Ganaraska River.

The Chalk Carriage Works manufactured lumber wagons, cutters and carriages and provided blacksmithing as well.

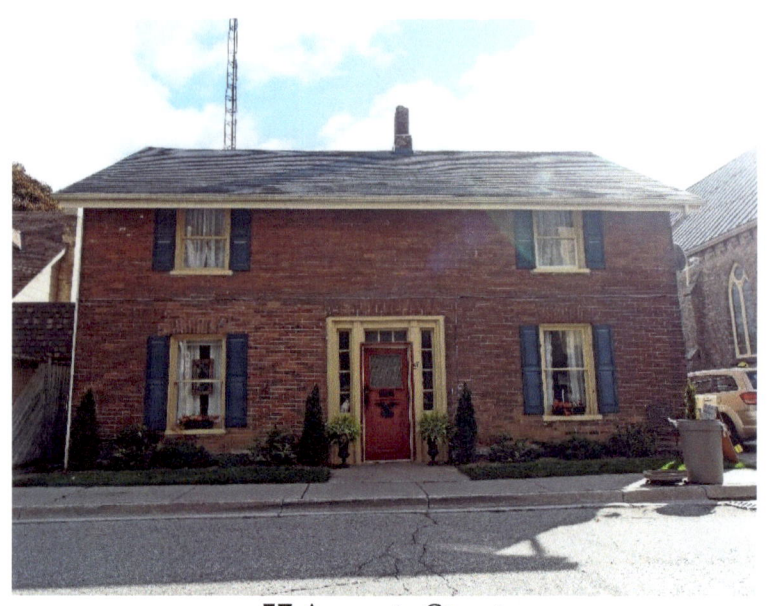
57 Augusta Street

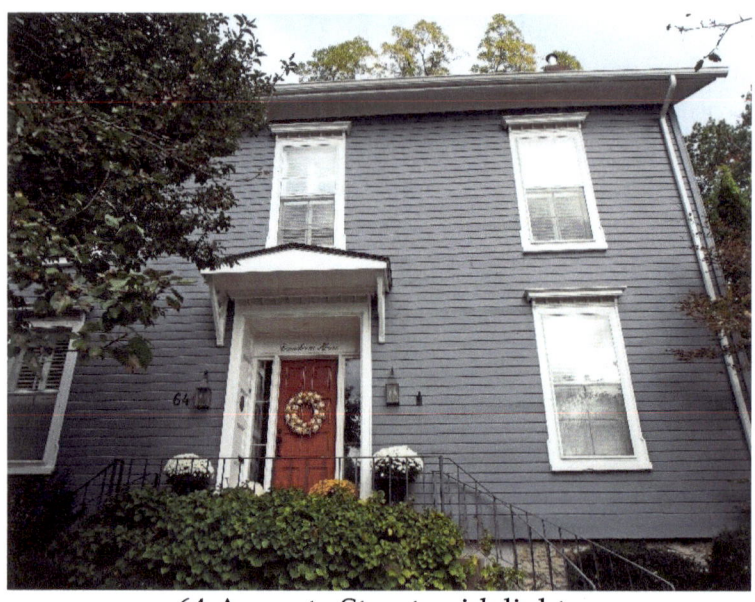
64 Augusta Street - sidelights

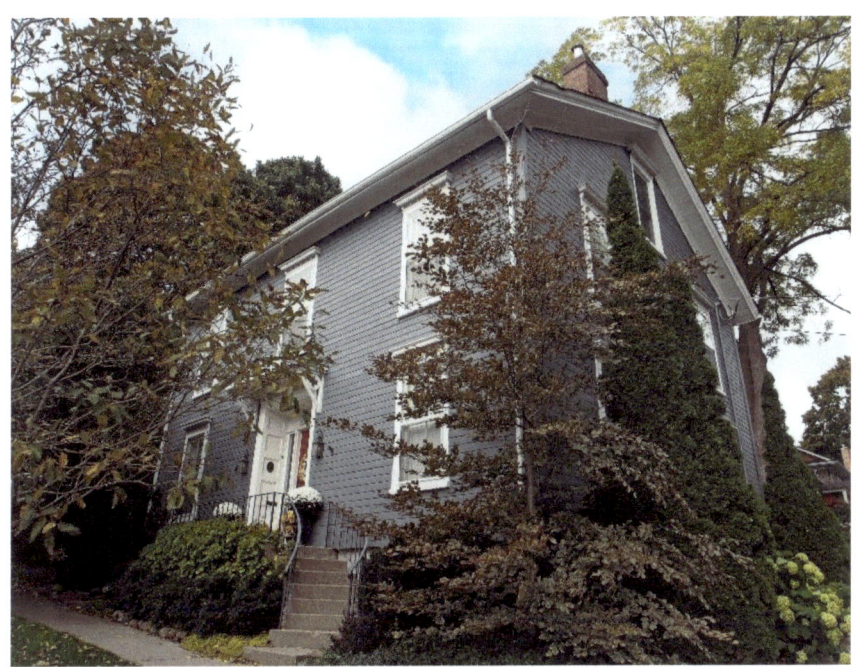

64 Augusta Street - William B. Cawthorne House – c. 1852 - This is a Victorian interpretation of Georgian style. This frame dwelling, clad in clapboard, stands two and a half storeys tall with steeply pitched gable roof. The facade is three bays wide with side-lighted front door and panelled door case placed centrally. Over the front door is a small pediment marked with quatrefoil trim. Windows are narrow. Glazing is four-over-four pattern.

William B. Cawthorne was a prominent watchmaker and jeweller whose specialties included clocks, jewels and musical instruments. He was born in England in 1820 and established a jewellery store on Walton Street in Port Hope in the late 1840's.

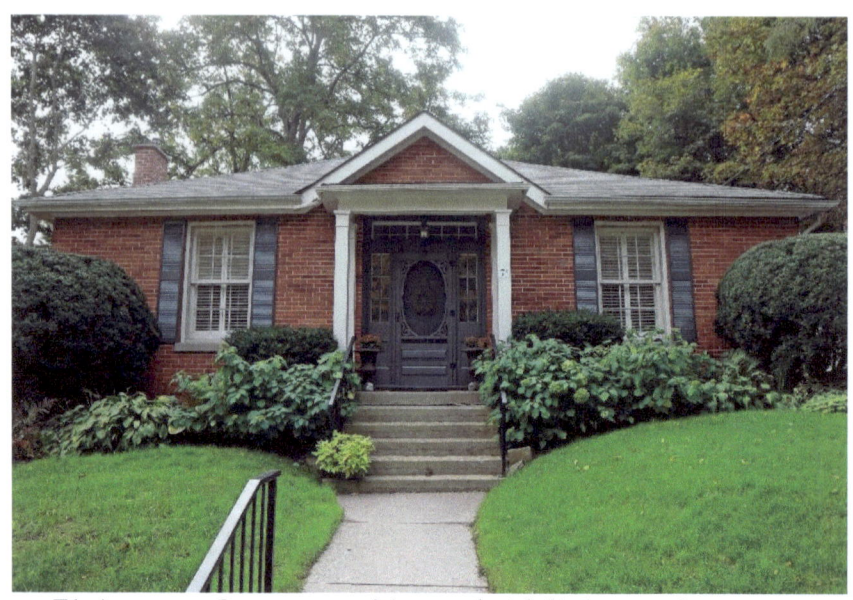
71 Augusta Street – multipaned sidelights and transom

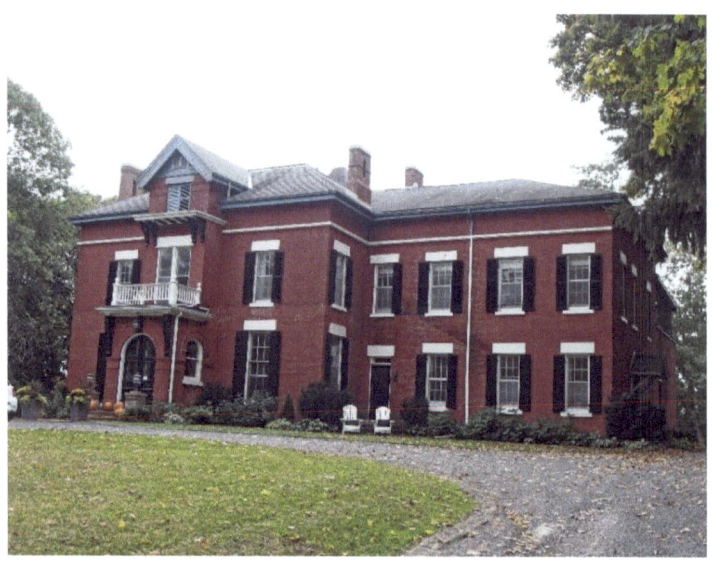
77 Augusta Street

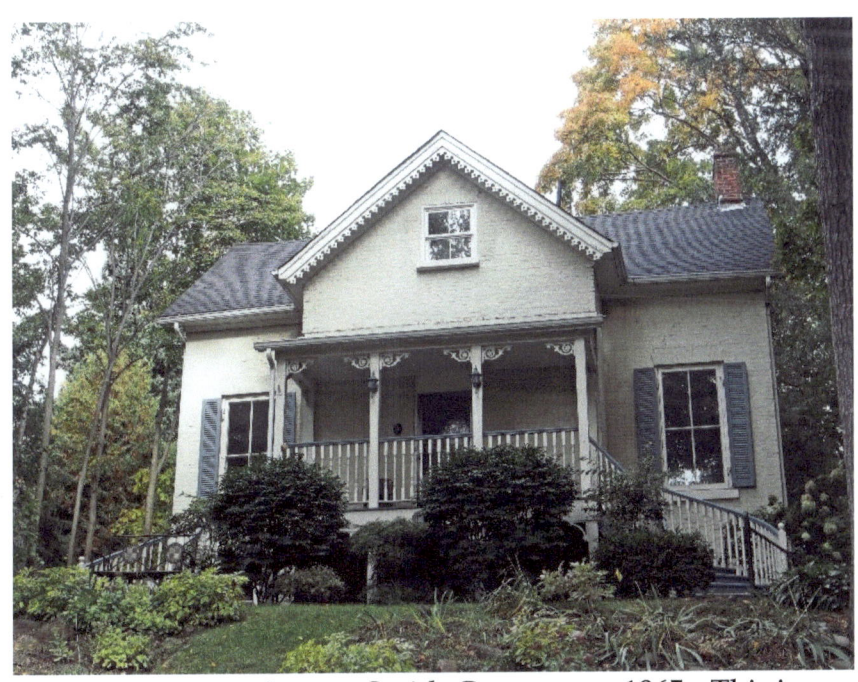

72 Augusta Street - Smith Cottage – c. 1865 - This is a 1½ storey brick cottage perched high on a hill with a grand overlook to the south. The porch was restored based on archival photos. The simple centre hall plan is punctuated by a protruding centre bay entrance.

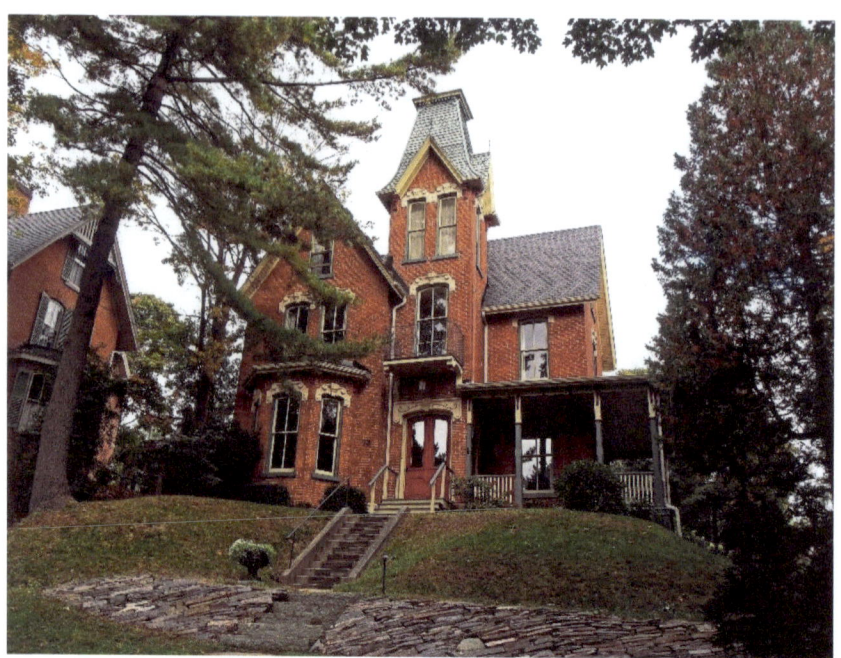

78 Augusta Street - Thomas McCreery House – c. 1875 - This is a late Victorian Italianate design, with the characteristic irregular plan, ell-shape to the front and with the tower crowned by a steeply pitched mansard roof, with a gable and with iron cresting to the small flat deck.

The ornamented window heads and door arch with their incised decoration, projecting keystones and scrolls are probably cast stone. Florid Renaissance detail, multi panelled doors and square towers are typical of the Italianate style. Brown and green were popular colours used on details.

Thomas McCreery was the proprietor of a billiard saloon on Walton Street during the late 1860s and early 1870s. By the 1880s, he was a grocer on Mill Street, and later sold ale and porter from a shop located in the Robertson Building at the corner of Queen and Walton (35 Walton Street).

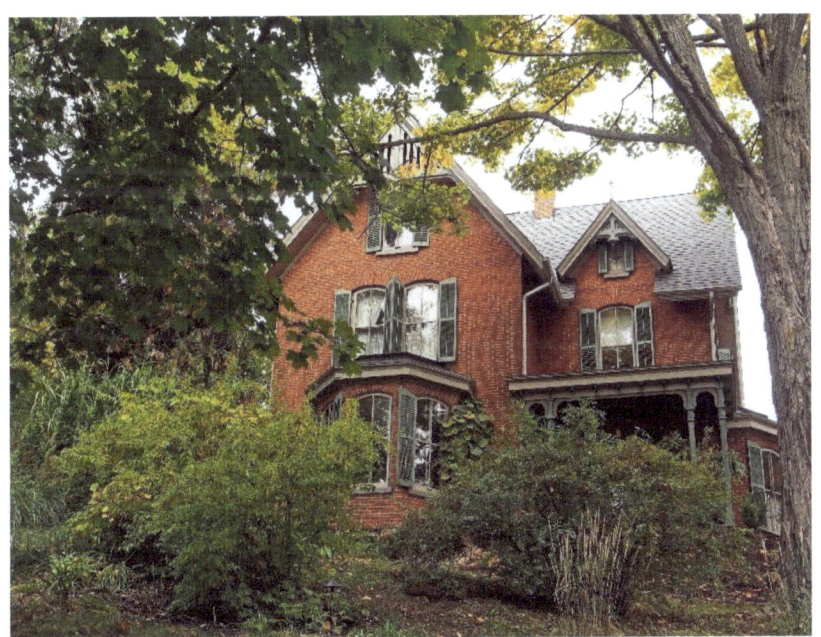

82 Augusta Street - Judson A. Brown House – c. 1880 – The two-storey late Victorian manor house has high peaked gables that accentuate the irregularity of the T-shaped or cross-gabled plan. The gables have exaggerated wood trim and finials and broad wood fascias. The front elevation features a one-storey bay window with large curved head windows. A unique feature of the house is a "coffin" window, a window that could accommodate the passage of a coffin through it. In the 1880s when wakes were held at home, it was considered bad luck for a coffin to enter by a door.

Judson A. Brown. Brown was born in Ontario of Scottish descent in 1836. He married the niece of John Riordan, Emeline Loretta Riordan, in 1859 in Port Hope. After being in practice for ten years, he established an office in Port Hope in 1865. In 1880, he had a dental practice located on Walton Street over the Skitch Tailoring shop. He and his wife had four children born between 1861 and 1874 no doubt necessitating the need for a large house. The Brown family resided at 82 Augusta Street for forty years until 1920.

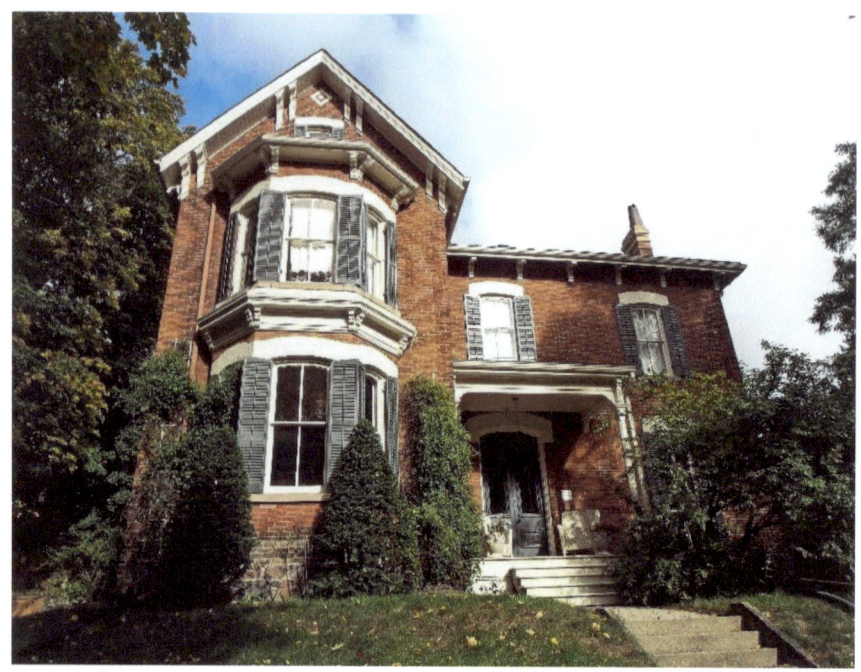

86 Augusta Street - James Leverich House – c. 1877 - The house is a good example and characteristic of a mid-Victorian villa in the picturesque manner. Two storey bay windows and paired brackets to eaves are typical of late Victorian houses. The basement wall material is rubble, and the brickwork is stretcher bond. There is one chimney on the east side of the house and two on the left, or west side, all made of brick. The main door surround is of plain wood.

In 1887, James S. Leverich purchased the property. Leverich (1828-1892) was born in Otisco, New York. By 1857, he had established himself as a merchant selling groceries and liquors on Walton Street. By the early 1870s, he established a business as a lumber merchant selling lumber, lath and shingles. The house remained in the Leverich family until 1920.

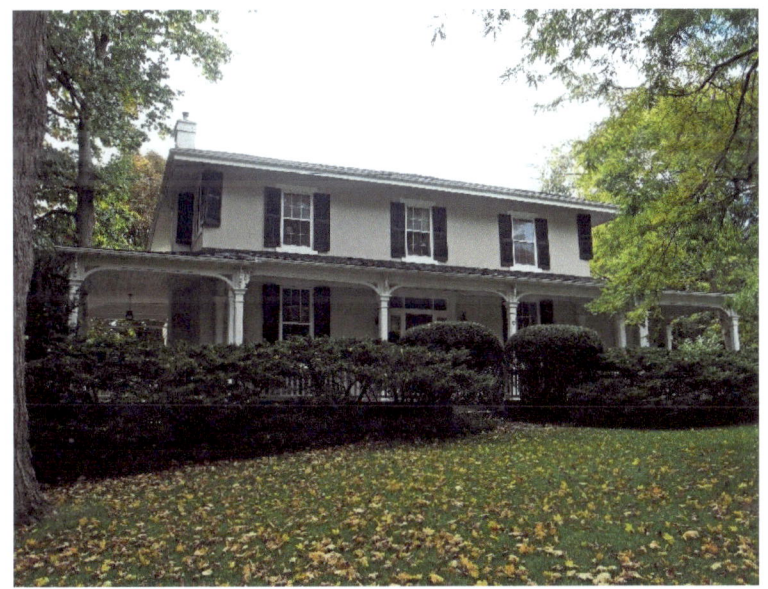

87 Augusta Street

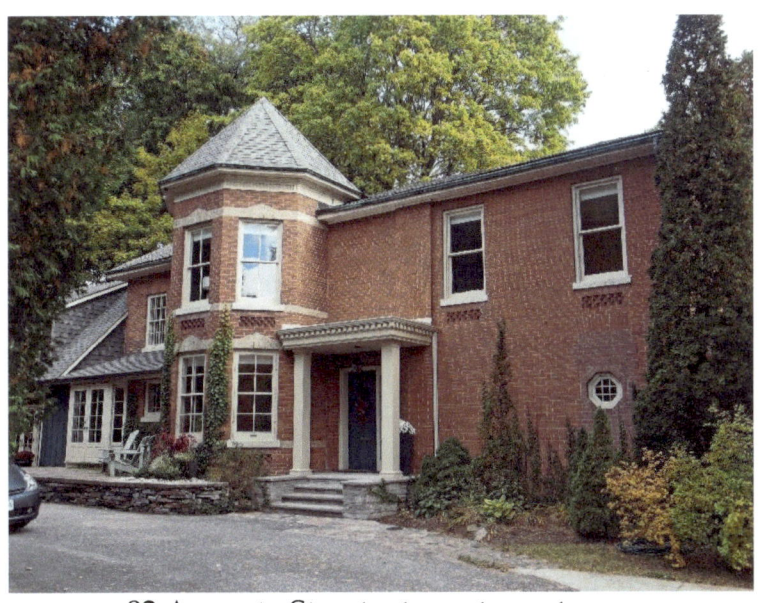

92 Augusta Street – two-storey tower

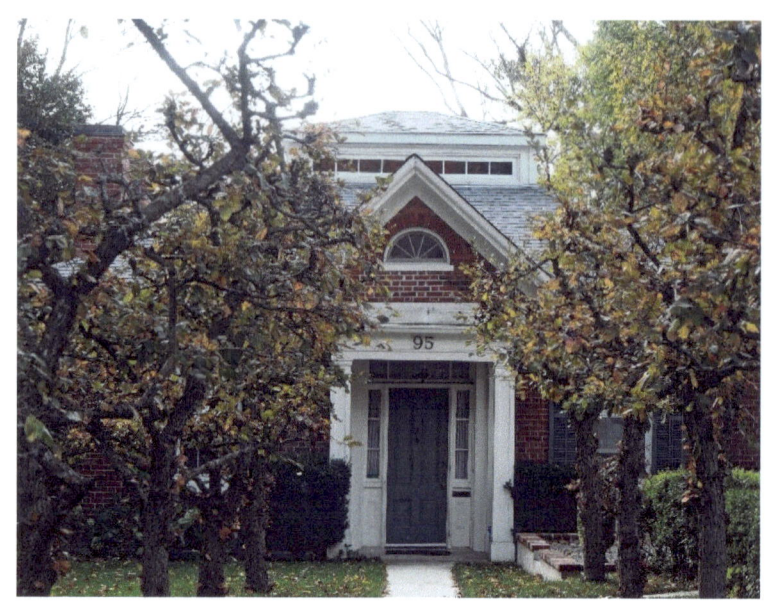

95 Augusta Street – sidelights, transom, fanlight in gable, belvedere on rooftop

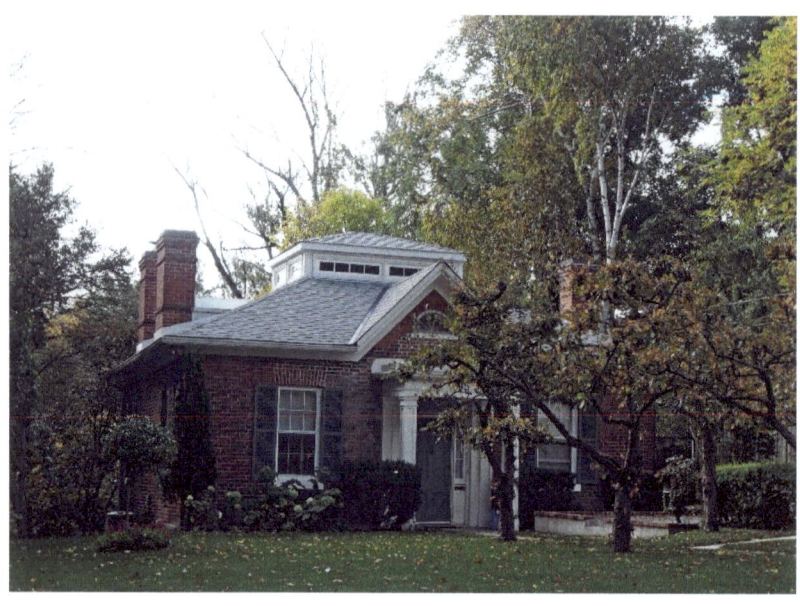

99 Augusta Street

101 Augusta Street

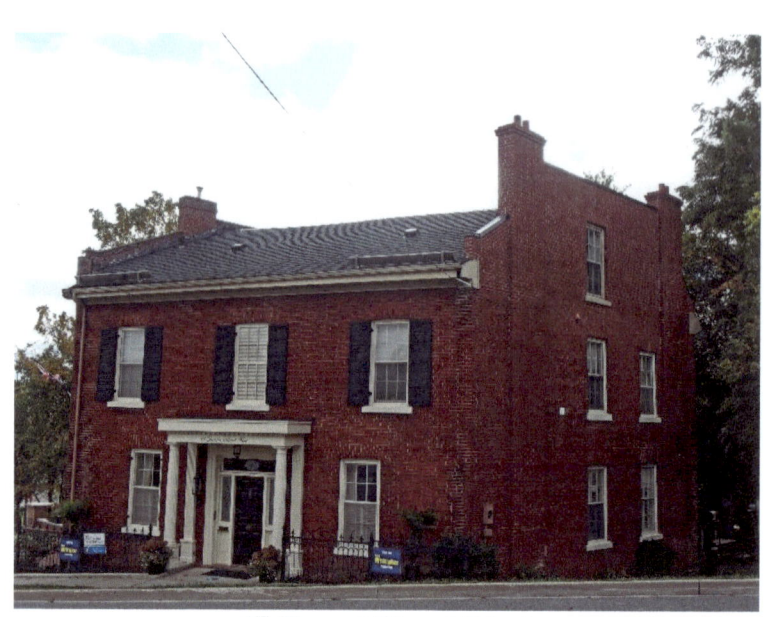

45 Dorset Street West

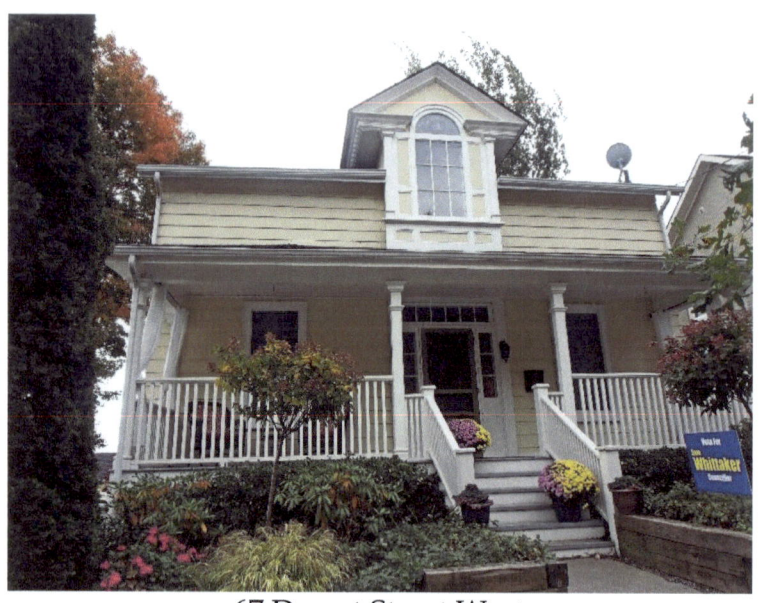

67 Dorset Street West

69 Dorset Street West

71 Dorset Street West

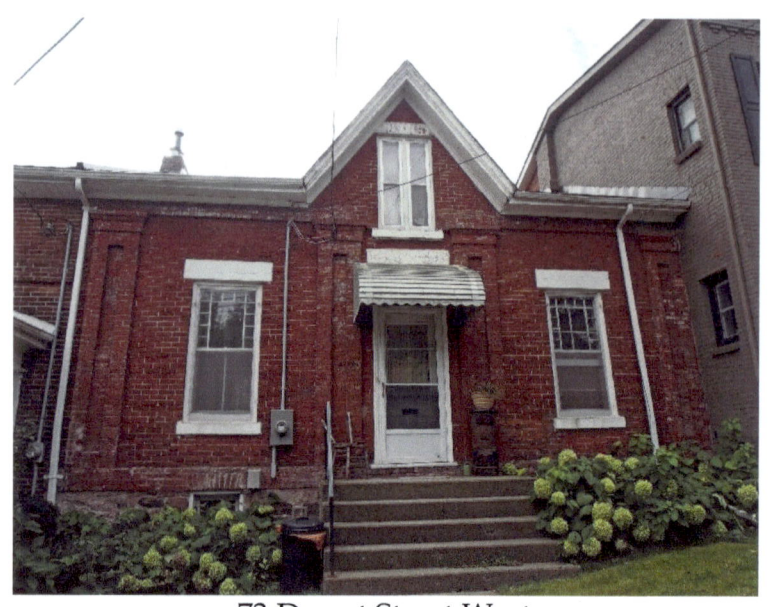

73 Dorset Street West

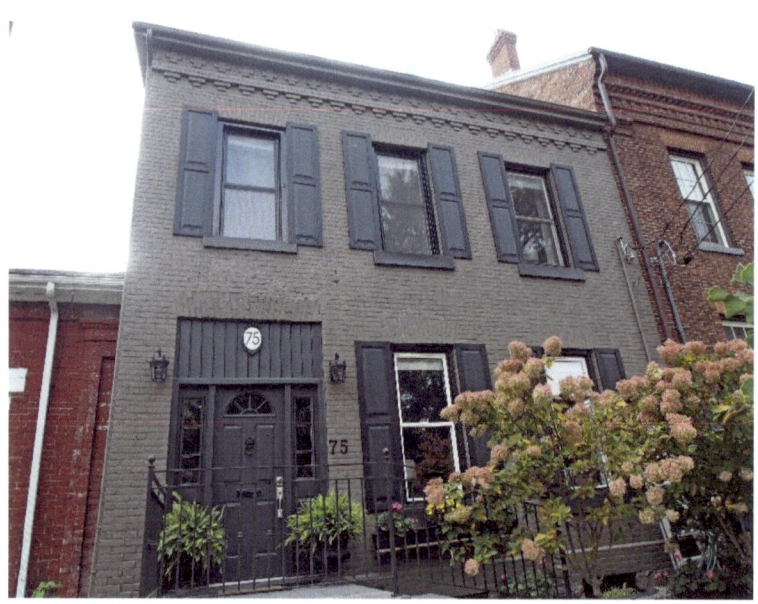

75 Dorset Street West – decorative cornice

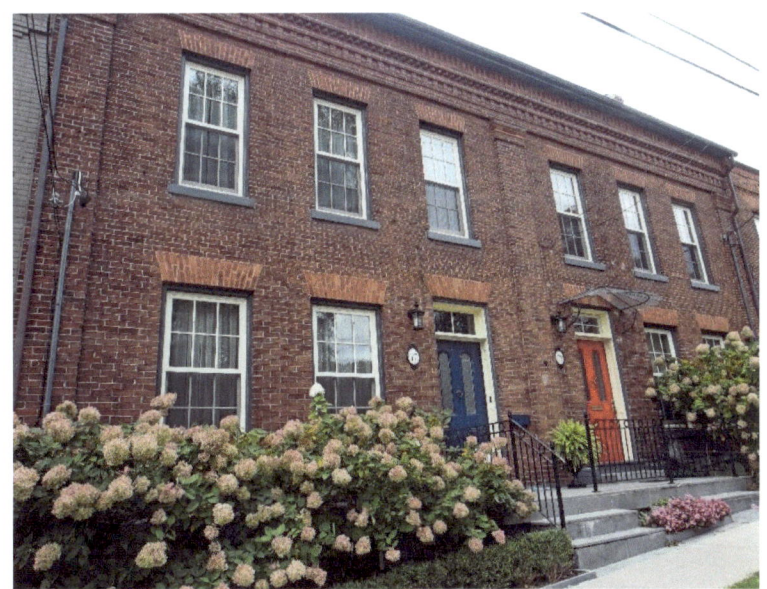
77-79 Dorset Street West - decorative cornice

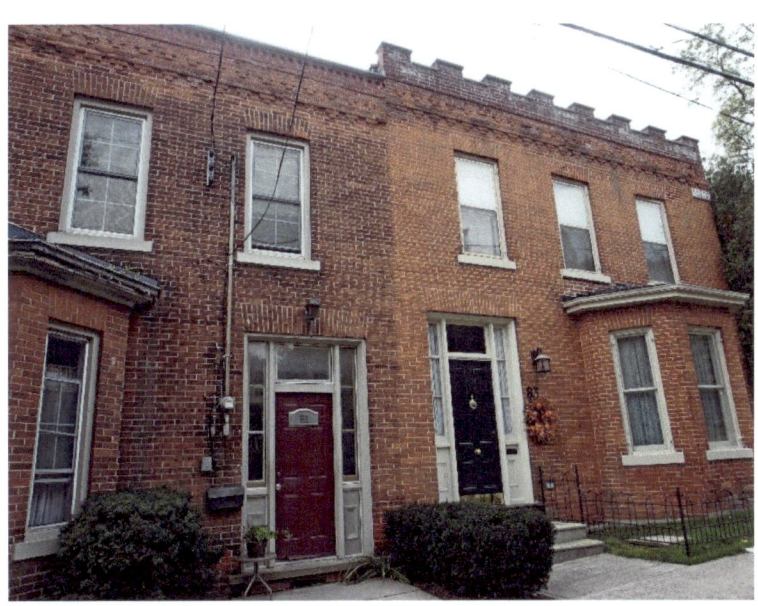
81-83 Dorset Street West – battlemented parapet, bay windows

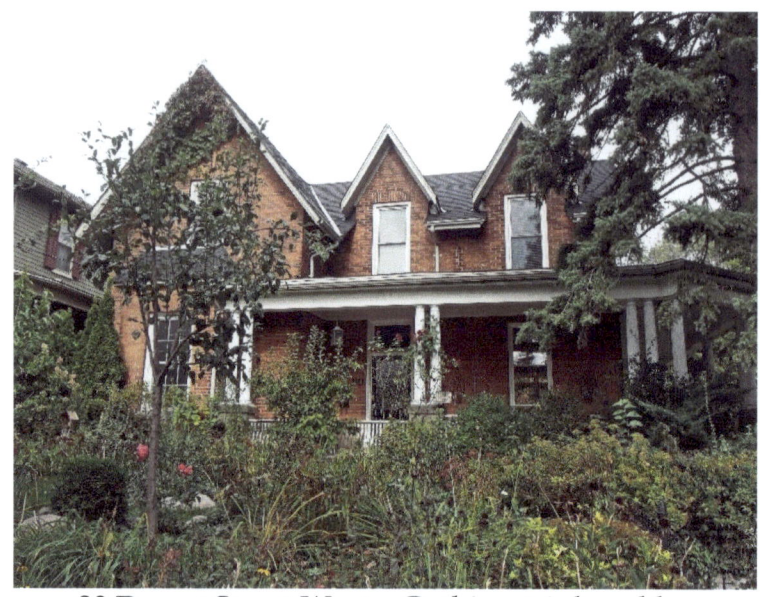

80 Dorset Street West – Gothic – triple gables

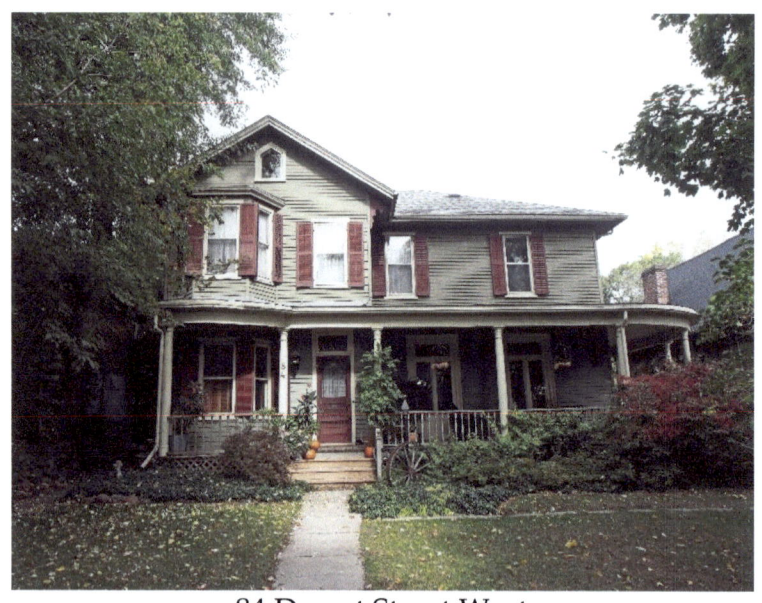

84 Dorset Street West

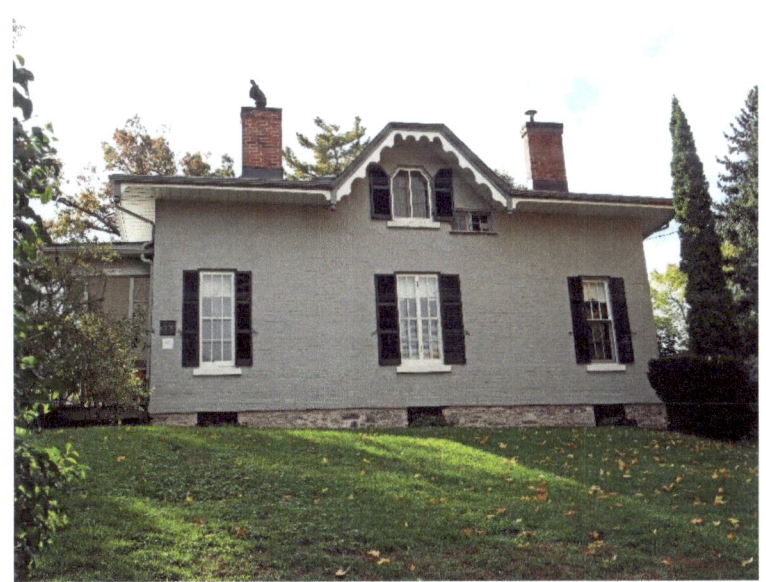

89 Dorset Street West - William Sisson House (Wimbourne) – c. 1853 - The well-balanced square house exhibits features of the Regency style. The roof is a variation of the truncated hipped roof with a medium pitch. On each side there is a centre-hipped gable with attractive bargeboard.

William Sisson (1801-1885) born in Rhinebeck, Dutchess County, New York built Wimbourne House. He emigrated to Port Hope in June 1823. His wife, Elisa Ann Walton, was born in Upper Canada in 1805. He manufactured leather.

Mr. Sisson, father of four children, was an active member of the Durham Agricultural Society and served as its treasurer for forty years. He was an active promoter of the first Mechanic's Institute, and raised and commanded a troop of cavalry (attached to the Durham Regiment), which assisted in the suppression of the rebellion of 1837-38.

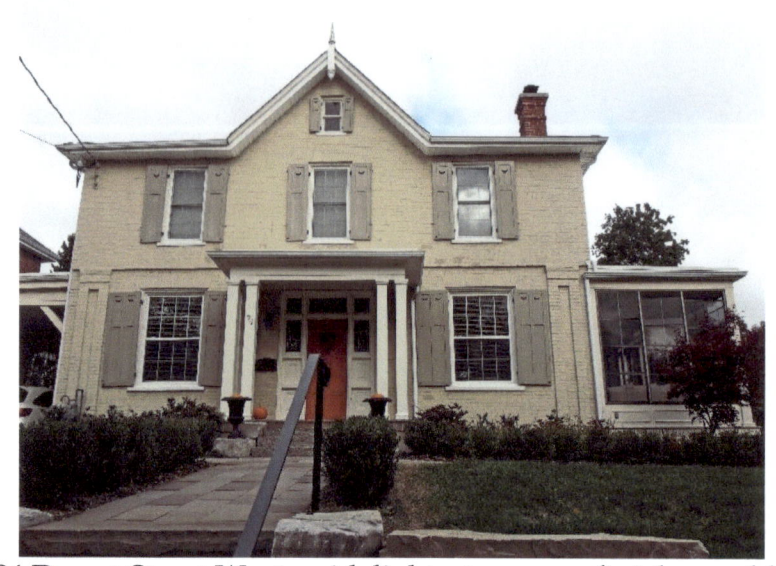

94 Dorset Street West – sidelights, transom, finial on gable

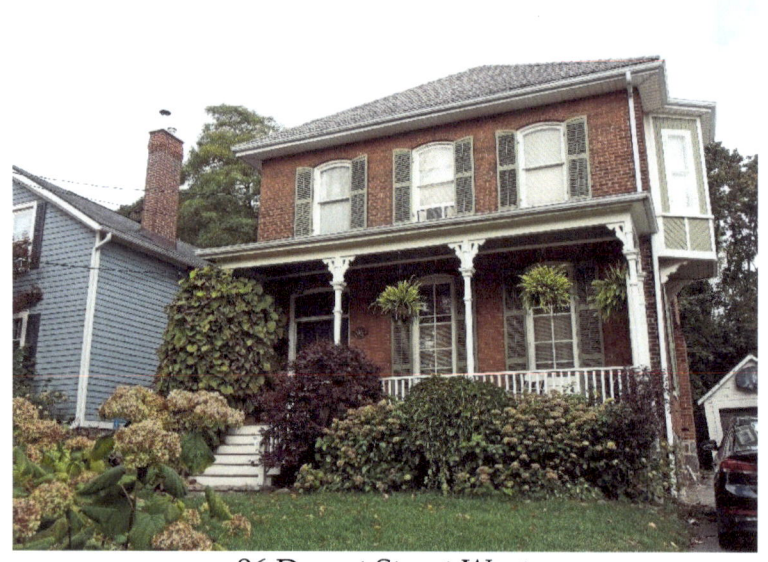

96 Dorset Street West

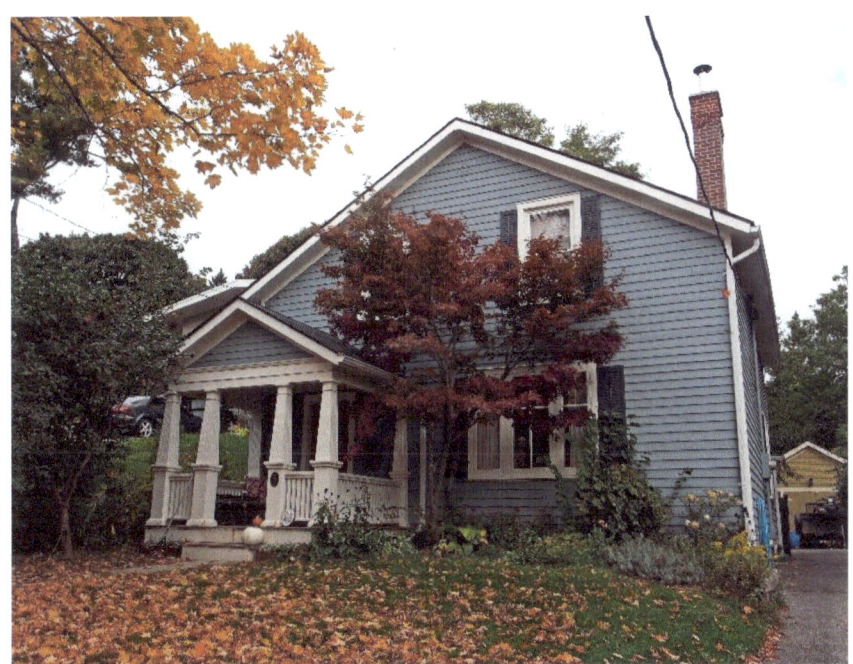

98 Dorset Street West - Peter Rice Randall House - original circa 1853, modified circa 1890-1910 - The house is a well-maintained frame two-storey cottage. The plan is a simple side stair with two main rooms on the ground floor with a kitchen in a rear frame one-storey appendage. This simple house is adorned by a generous front porch with wood tapered columns. The columns, while simple, have an interesting wood detail replicating flutes. The windows on the ground floor main rooms are a cottage-style double-hung window with six panes over and a larger tower single pane window. The rear kitchen has six over six windows. On the second floor are simple double hung windows with single pane glass.

Peter R. Randall (1822 - 1906) was born in Ontario in 1822, and had established himself as a carpenter and builder during the prosperous 1850s in Port Hope. His father, John P. Randall was of Loyalist stock.

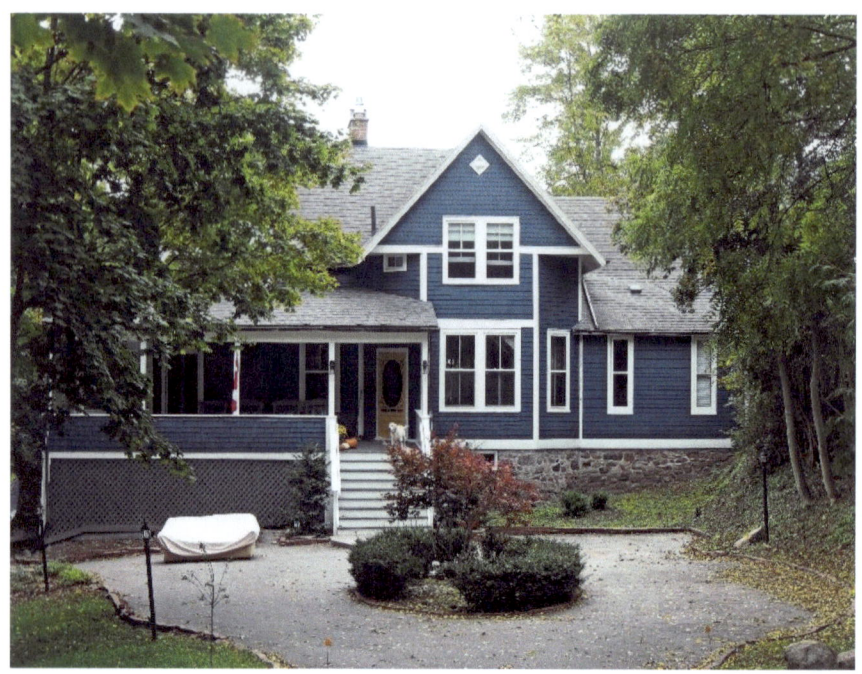

105 Dorset Street West - Bredon House – c. 1880 - This the Queen Anne Revival house is often called the Shingle Style. The house is a high storey and a half frame building facing north to Dorset Street and, because of the steep hillside property, on the south side is set over a full storey basement built of squared fieldstone. The highly ornamental and picturesque Dorset Street front is marked by a wide bay dominated by a gable overhanging the splayed sides and another smaller gable adjacent, both with paired windows. A verandah wraps around the end of the house, to become an open deck across the south face. The house was modified in 1900, 1970 and 1986.

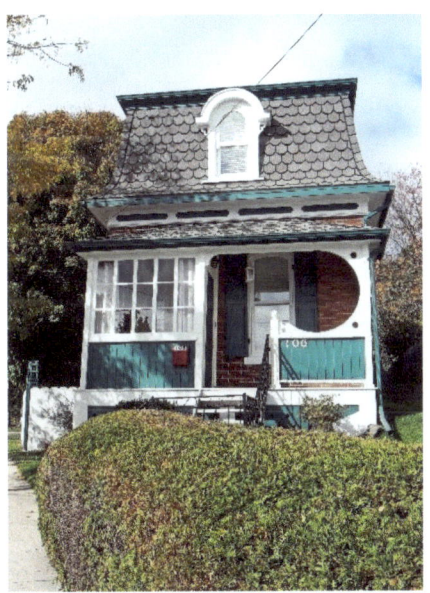

106 Dorset Street West

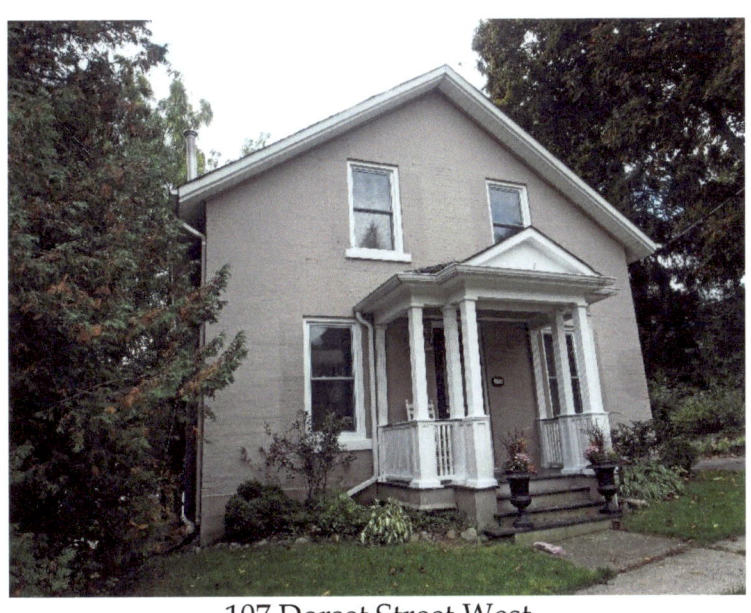

107 Dorset Street West

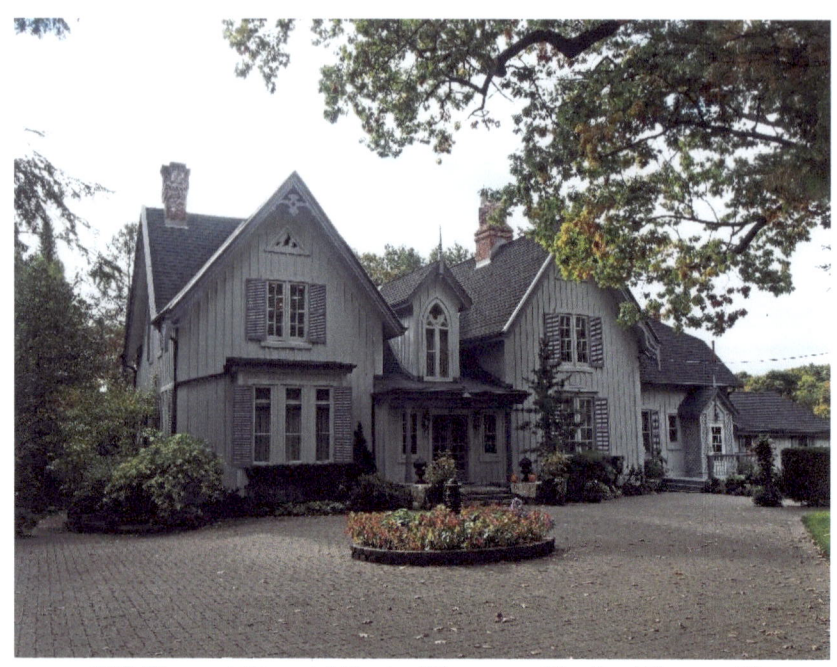

115 Dorset Street West - Thomas Clarke House (The Cone) – c. 1858 - The one and a half storey grey board and batten house incorporates some elements of the Gothic Revival style. It has steeply pitched gables, the appearance of irregularity because of complex roof patterns, pointed arched openings such as the gothic window above the doorway, and decorative details including the quatrefoil window tracery in this same window, the bargeboards in the gable peaks and the finial. A notable feature of the exterior is, the board and batten, was preferred by Downing for he believed that it was more economical than clapboard, and because it was a bolder method of construction, it better expressed the picturesque beauty essentially belonging to wooden houses. The main facade has three pairs of four over four double-hung sashes, a bay projection containing three casement windows, and five six over six double-hung sashes. The central double doors each have twelve windowpanes.

The original owner, Thomas Curtis Clarke (1827-1901) was associate engineer and secretary of the Port Hope, Lindsay and Beaverton Railway, and later advisor for the Harbour Board at the reconstruction of the harbour in the 1850's. His wife Susan Harriet Smith (1837-1909) was a daughter of John David Smith (1786-1849) who built the Bluestone (21 Dorset Street East), and granddaughter of Port Hope founder, Elias Smith.

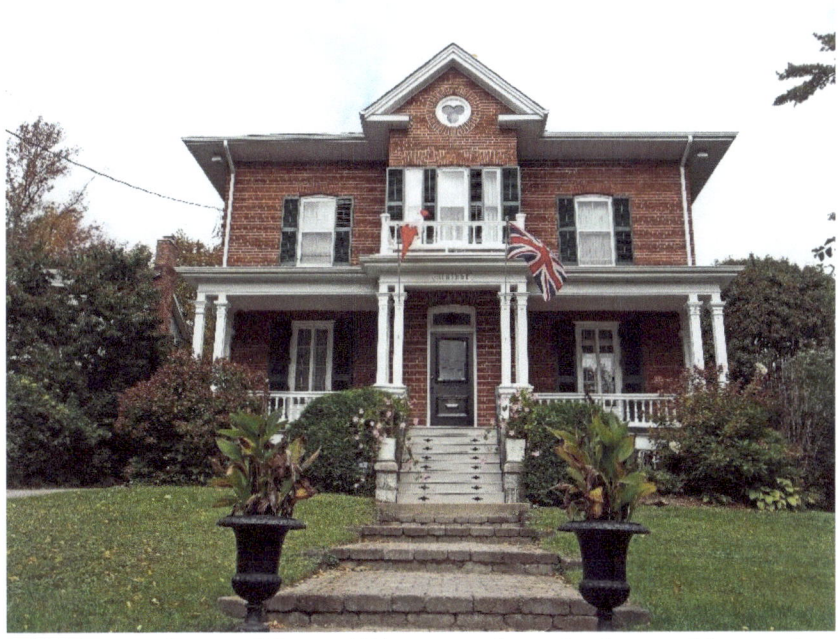

108 Dorset Street West – 2½-storey frontispiece with cornice return on gable and trefoil window

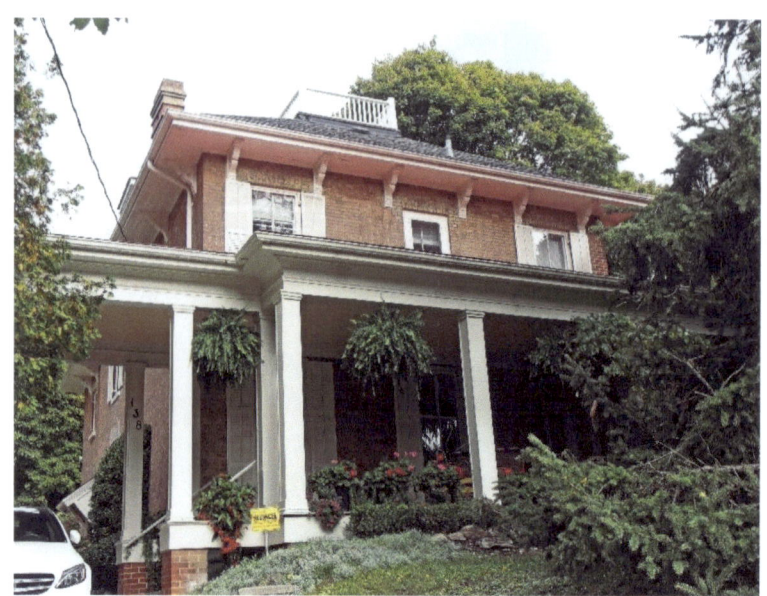

138 Dorset Street West

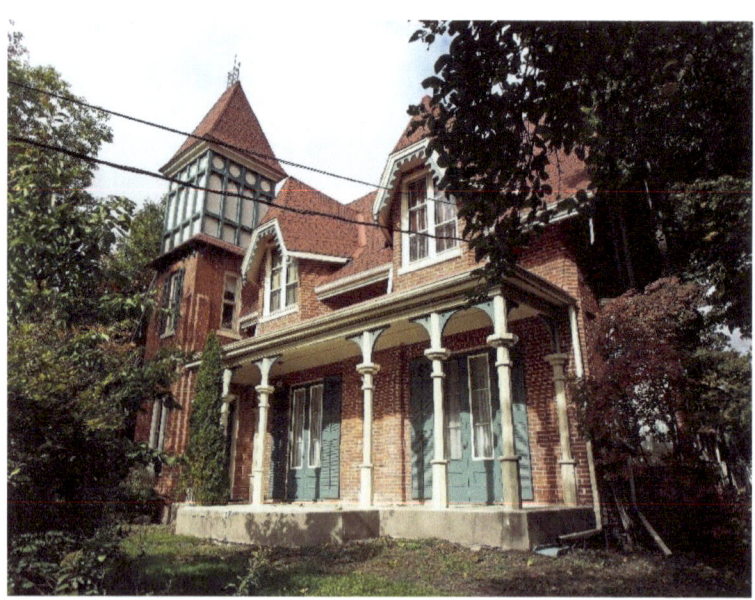

160 Dorset Street West – c. 1859 - Terralta Cottage - note unusual window gables, called nun's coiffe dormers

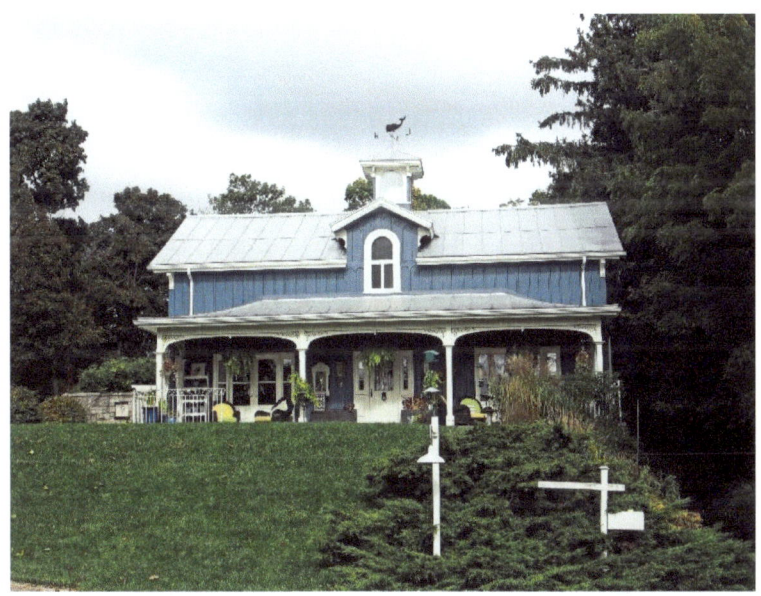

150 Dorset Street West - c. 1869 - Idalia Carriage House was moved to 150 Dorset Street and modified circa 1975. It was constructed on the grounds of the nearby Italianate mansion, Idalia, built about 1869. Idalia once stood on six acres originally severed from the Thomas Gibbs Ridout land holdings overlooking the lake at the southern most point of Victoria Street.

Idalia was built for Charles Seymour and his wife Emma. Charles was the son of the Honourable Benjamin Seymour who built his stately home on Pine Street (71 Pine North). Emma was the daughter of John T. Williams who resided at nearby Penryn Homestead (82 Victoria Street South). Emma's brother, Arthur T.H. Williams also resided nearby at Penryn Park (82 Victoria Street South), and he was married to a Seymour daughter, Emily.

The carriage house was modified from its former use to be used as a home while preserving many original features. The house underwent a complete reconstruction with its cupola being restored.

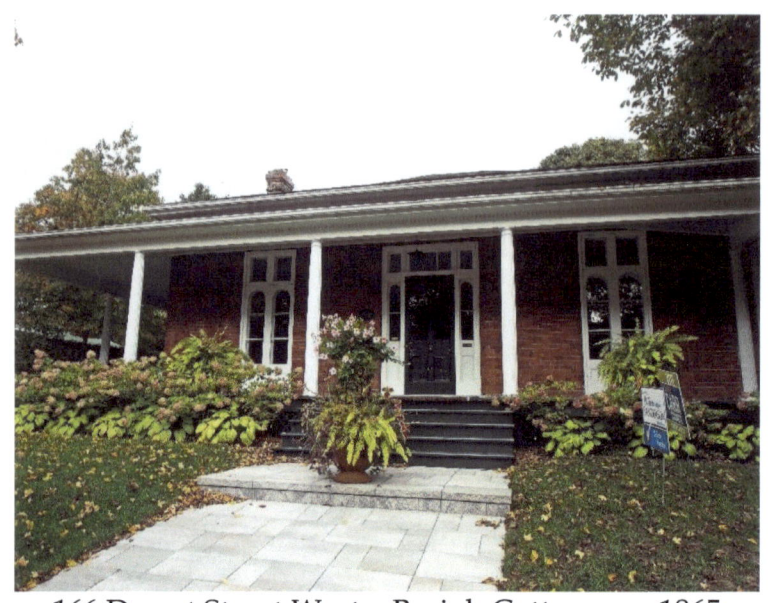

166 Dorset Street West – Braigh Cottage – c. 1865

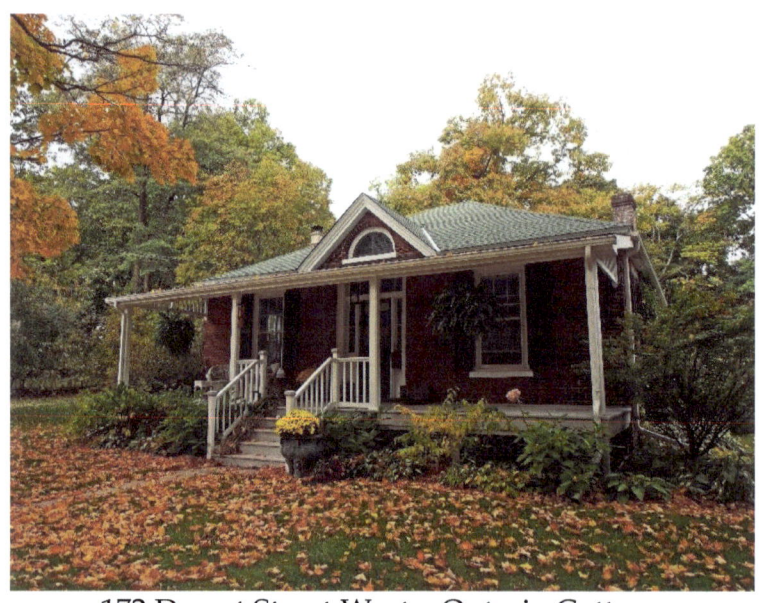

172 Dorset Street West – Ontario Cottage

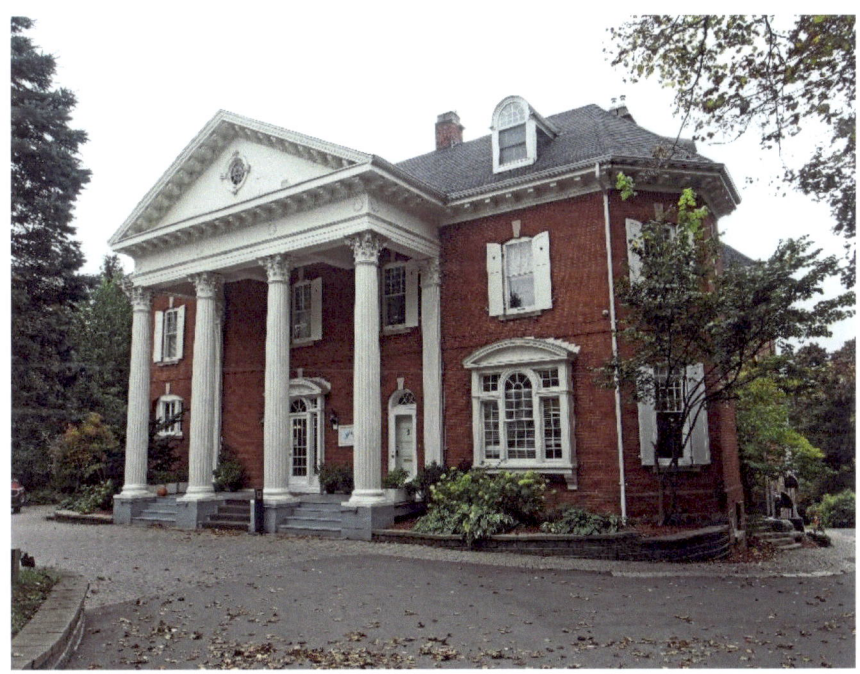

175 Dorset Street West - David Smart House (The Hillcrest) – c. 1870 - This house is the only example of "Beaux Arts" architecture in Port Hope. An addition to the house was made around 1900 which consists of the large Jeffersonian portico on the north. This massive two and a half-storey structure is held by fluted columns with large Corinthian capitals, the main original portion of the house is hipped roof section with two polygonal wings at each end. This section sports beautiful Palladian dormers, bracketed eaves and a grand verandah.

The house was built for David Smart, a barrister and notary public who married Emily A. Worts of Gooderham and Worts Distilleries of Toronto. Smart became a director of that distillery.

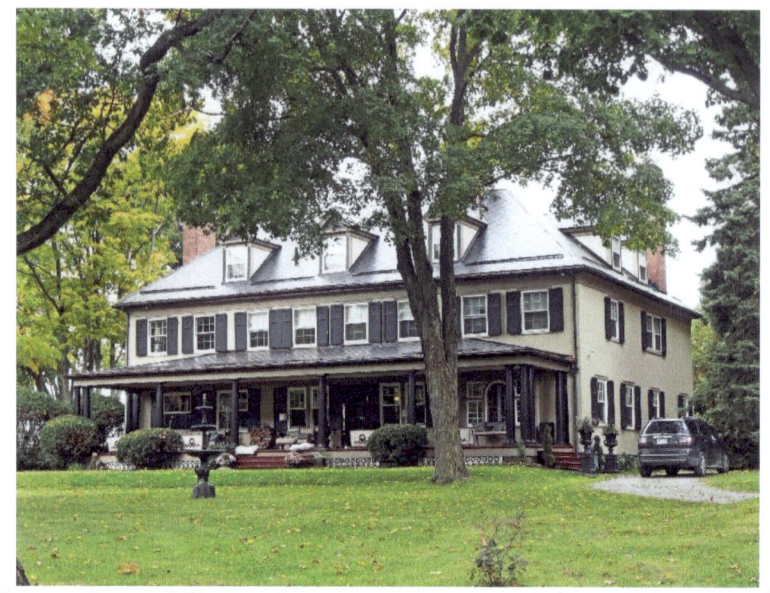

Dorset Street West – dormers, shutters, full-width veranda

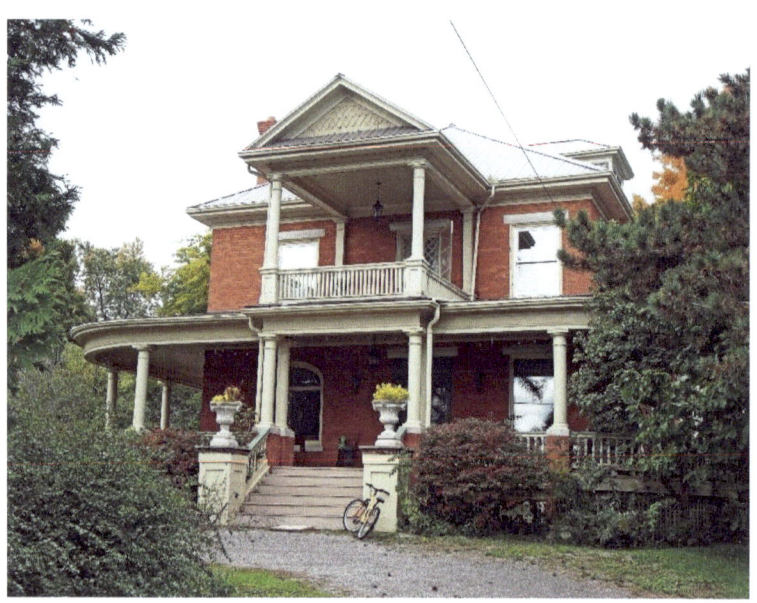

54 Dorset Street East

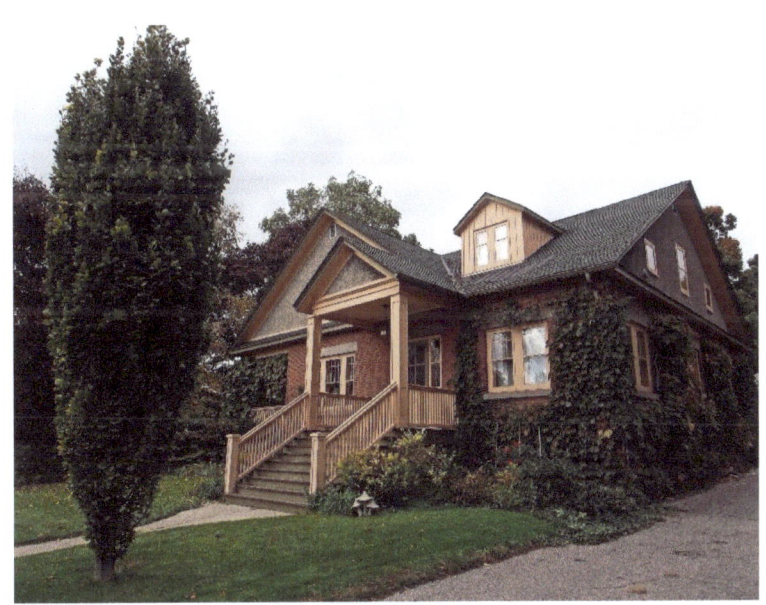

46 Dorset Street East

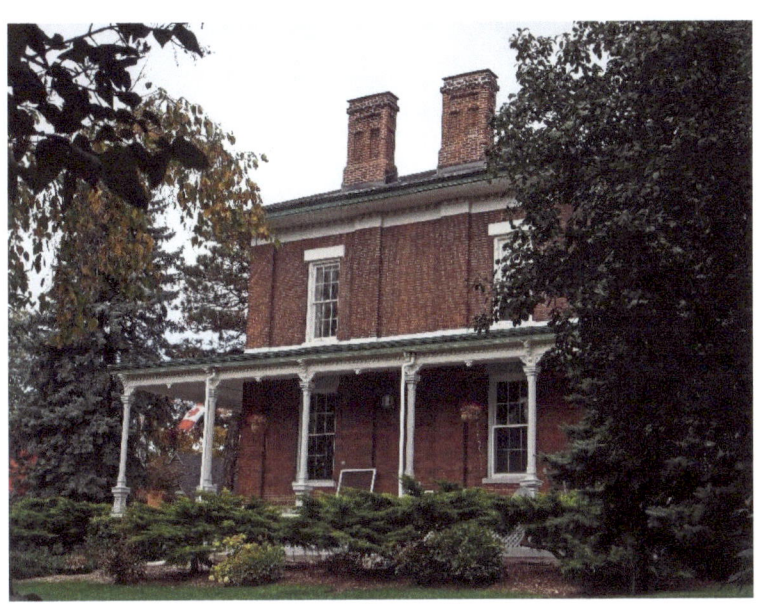

Dorset Street East

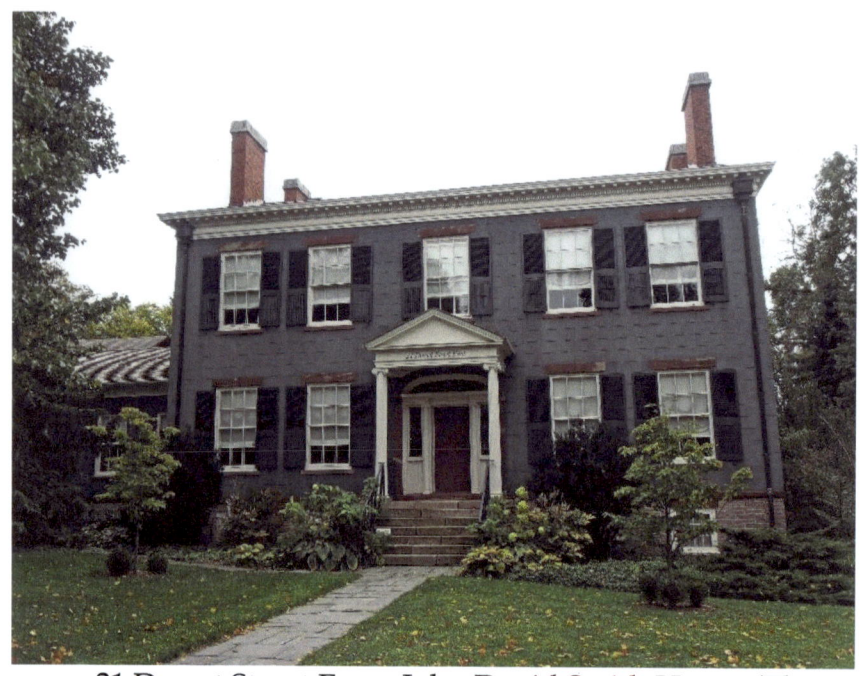

21 Dorset Street East - John David Smith House (The Bluestone) – c. 1834 - The two-storey house is rectangular in plan. The basement is of random rubble and the four end chimneys are brick. The style of the house is Greek Revival. Although the symmetry and the rectangular plan are typical of the Georgian style, much of the exterior and interior detail is definitely Greek in derivation. The house is well-proportioned and balanced with nine windows on the main and rear facades and six windows on the west end (one false).

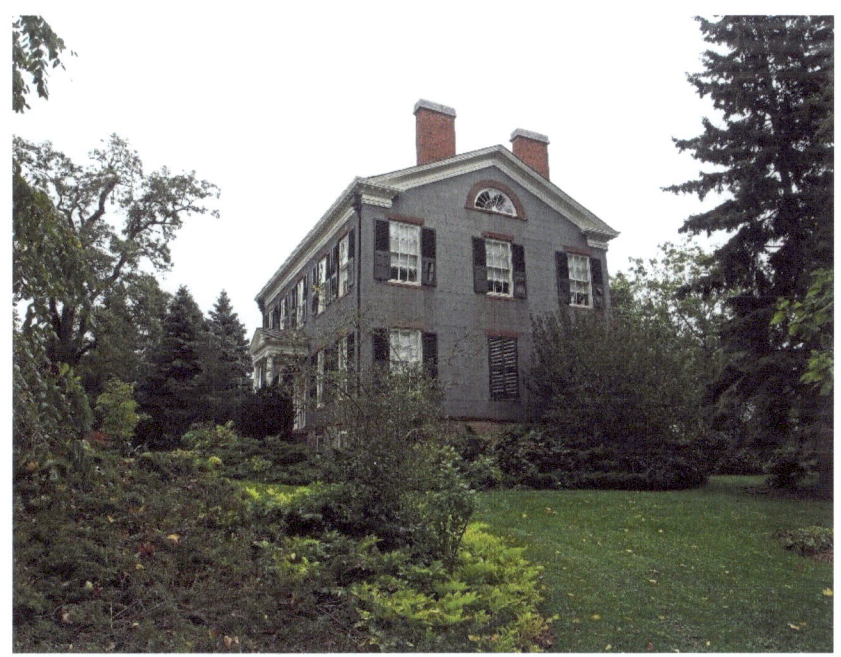

21 Dorset Street East - All the windows are six over six double hung sashes. A small semi-circular radiating fan window punctuates the west end under the gable. The structure has a medium pitched gable roof with returned eaves on the gable ends, a bracketed cornice, and a moulded architrave under the eave. The porch has Ionic fluted pillars, which provides an element of simple yet imposing grandeur. The recessed, broad, six panel door is accompanied by fluted pilasters, sidelights with fine tracery, and semi-elliptical fan transom. The surrounding trim of red sandstone is molded and carved with classical motifs.

Other Books by Barbara Raue

Coins of Gold
Arrows, Indians and Love
The Life and Times of Barbara
The Cromwell Family Book
Laura Secord Discovered
Daddy Where Are You?

Montana Series
Book 1: Montana Dream
Book 2: Life on the Montana Frontier
Book 3: Montana to Boston and Back
Book 4: Montana Sons Go to War
Book 5: Montana Sons Return from War

© 2019 by Barbara Raue - All the photos in this book have been taken with my cameras. I own the rights to them.

www.ingramcontent.com/pod-product-compliance
Lightning Source LLC
Chambersburg PA
CBHW041105180526
45172CB00001B/114